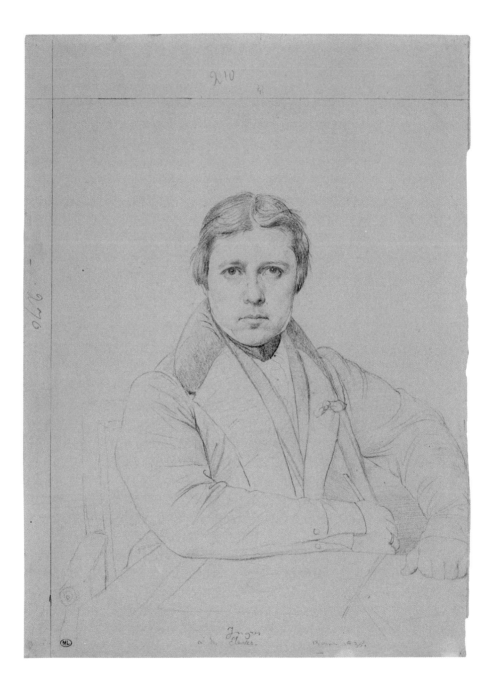

WILLIAM HAUPTMAN

INGRES

CONTINENTS

PAGE 2
Self-portrait, half-length, 1835,
Paris, Musée du Louvre, inv. RF 9.

EDITORIAL COORDINATOR
Paola Gallerani

EDITING
Andrew Ellis

ICONOGRAPHIC RESEARCH
Massimo Zanella

CONSULTANT ART DIRECTOR
Orna Frommer-Dawson

GRAPHIC DESIGN
John and Orna Designs, London

LAYOUT
Virginia Maccagno

COLOUR SEPARATION
Cross Media Network srl (Milan)

PRINTED FEBRUARY 2006
by Conti Tipocolor, Calenzano (Florence)

© 2006 – 5 Continents Editions srl, Milan
info@5continentseditions.com
ISBN 88-7439-263-x

PRINTED IN ITALY

CONTENTS

Opening quotations of each chapter are taken from: Gustave Kahn, "Ingres et Manet" (*La nouvelle revue*, 15 October 1905, pp. 55–59): p. 7; and Pierre Courthion, *Ingres raconté par lui-même et par ses amis: Pensées et écrits du peintre* (Geneva–Vésenaz: P. Carlier, 1947–48, 2 vols.): pp. 9, 10, 16, 18, 25, 29, 31, 34.

"Dans ses portraits et dans ses dessins, [Ingres] se donne, tandis qu'en
son œuvre officielle de décoration ... il se garde, et la recherche de la belle
ligne ardente qu'il a en ses portraits le met très près de chez nous,
le met assez près de Manet."

PREFACE

Among the most eminent French painters of the nineteenth century, few are as
difficult to classify within the standard definition of style as is Ingres. His paintings,
though not his drawings, remain far from popular with the museum-going public,
perhaps because they straddle uncomfortably difficult planes. They in fact embody the
foundations of the perpetual debate of the demarcation and limits of the polar
classifications of Neoclassicism and Romanticism, as so many contemporary critics
remarked. When Théodore Silvestre provided the celebrated definition of the painter
in 1855 as a "Chinois égaré dans les rues d'Athènes," he crystallised the equivocal
position Ingres assumed. But Ingres' long life spanned many major art movements in
France and abroad, as well as the political turmoil of three revolutions. This historical
context can be grasped further when one considers that Ingres was born nine years
before the traumatic upheaval of the French Revolution, and died only seven years
before the first Impressionist exhibition. It is still difficult to conceive that Ingres was
alive when Kandinsky was born (1866).

This contradictory figure, as iconic as the times in which he lived, can be
comprehended therefore in a variety of ways, but hardly by Ingres' own words. His
writings contain little of his personal enthusiasms, intrigues, or individual passions
outside of his imperial aphorisms on art culled by adoring students later. A
photograph of him in old age, solemnly dressed in formal wear, suggests the air
befitting a bourgeois of the Second Empire, the dignified, sober, sedate "M. Ingres" of
legend. This image accords with the one that has been passed down of a painter who
judiciously followed the harsh and sometimes unyielding artistic rules established by
his master David; in effect, a conventional painter wedded to a certain ideality and

maniacal perfectionism who rarely wavered from the theories of beauty he zealously espoused. But comparing the photograph to Antoine Bourdelle's portrait bust of 1908, another side of the painter bursts forth. Bourdelle, who like Ingres was born in Montauban, presents him with Rodinesque boldness erupting with physical energy, his eyes peering into a visionary space, a ruggedness that hardly accords the staid image the painter projected for the camera lens. Like Rodin's celebrated image of Balzac, Bourdelle's portrait appears to detonate a creative energy from within that belies the dogged labels usually placed on him.

Such paradoxes were not lost on early modern painters, who found some of the incongruities inherent in Ingres' styles ample fuel for visual articulation. The curious appearance of a small exhibition of Ingres' paintings in the Salon d'Automne in October 1905—in which Ingres was contrasted with Manet and where Louis Vauxcelles first labelled the Fauves—seems such an incongruous setting that *Le Figaro* of 19 October 1905 accentuated the anachronism. In a cartoon, a critic asks the painter: "What surprises you the most in the Salon d'Automne, M. Ingres?", to which he replies: "It's to see myself here." Ingres', not Donatello's, presence among the Fauves, nevertheless had a surprising impact on such painters as Matisse and Picasso, who perceived a modernity that escaped the perception of earlier painters. Matisse reacted accordingly with such paintings as the *Bonheur de vivre*, a modern expression of Ingresque bathers, while during Picasso's more classical phase of 1915–25, one may properly speak of an "Ingresque" stylistic root that pays homage to him and carries the singularity of Ingres' works further along its modern path.

Ingres' familiar departures from artistic dogma—what critics would call his "bizarreries"—also aroused the interests of the Dadaists and the Surrealists, who saw nourishing seeds in Ingres' less iconic images. The most noted of this curious association is Man Ray's whimsical photograph of 1924, *Le Violon d'Ingres*. The model in this photograph, Alice Prin, the celebrated Kiki of Montparnasse, is consciously wearing a turban that is meant to recall the *Bather of Valpinçon*, one of Ingres' illusory paintings. But through Ray's addition of the musical sound-holes in ink, Kiki becomes transformed into the violin itself, the very instrument of the title. Ray's waggish title, which means a hobby or a distraction, is a reference to Ingres' passion for the violin, which he played with professional ease. But it is also a tribute to Ingres' highly erotic female nudes, turned in Ray's Dadaist imagination in a malicious way, as he plays upon the words *violon*—the instrument—and *violons*, "ravish". However resourceful the levels of meaning, the inference is to the familiar metaphor of the female body as a musical instrument, thus defining in a single image Ingres' sensuality, musicality in painting, and odd stature in nineteenth-century French art.

BEGINNINGS

"Mes adorations sont toujours Raphaël, son siècle, les anciens,
et avant tout, les Grecs divins."

Unlike many pivotal figures in the turbulent history of French art, Jean-Auguste-Dominique Ingres' roots were provincial. He was born on 29 August 1780 in Montauban, a thriving commercial centre on the right bank of the Tarn, which linked it to Toulouse. The city had a small cultural life with an established literary society, but neither a museum, nor grand collections, and therefore offered limited prospects for painters outside of common commercial applications. Ingres' father, Jean-Marie-Joseph, a minor decorative artist, was responsible for Ingres' early cultural interests through his instruction in drawing and music, two lynchpins that sustained Ingres with aesthetic gratification for almost eight decades. Although little of significance has come down concerning Ingres' youth, it is known that his early education followed a standard path, but by the time he was nine, he showed precocious talent in signing his first known drawing, appropriately a study after an antique plaster cast.

Recognising the budding talent of his youngest son, Ingres *père* sent him to the Royal Academy of Toulouse when he was eleven. The Academy, founded by Antoine Rivalz in 1726, was granted royal patronage in 1750, the only artistic training institution outside Paris to have that distinction. Under Rivalz, the goal of the Academy was to instruct students in the *grande manière* of classical art and portraiture. Ingres' principal teachers at this stage were the painters Guillaume-Joseph Roques (1754–1847), Jean Briant (1760–99) and the sculptor Jean-Pierre Vigan 1754–1829), who guided Ingres in the essential rules of modelling, composition, and theory. In the next few years he would distinguish himself with several drawing prizes, so that at the age of thirteen he received a small stipend from the Academy for a fully modelled figure. In 1794, while continuing his art studies, Ingres began studying the violin with greater earnestness, playing in the local orchestra. Of these, a particularly refined miniature portrait of a man with an earring from the sixteen-year-old student reveals pl. 1 the sensitivity of touch that will become one of his hallmarks. From such beginnings, it is little wonder that more prizes followed until instruction in Toulouse could afford no further advances.

PARIS

"L'art n'est pas seulement une profession, c'est aussi un apostolat."

In August 1797 Ingres travelled to Paris to work with the undisputed master of the time, Jacques-Louis David, whose teaching studio was meant to pass the torch to the younger generation. The training David provided, with immense emphasis placed on drawing from casts and models, was in fact a preliminary phase for entering and then succeeding in the École des Beaux-Arts courses and competitions. This route was an important one for younger painters, particularly from the provinces, because it permitted artistic honing toward a style and technique that accorded with the judges, who would determine the *entrée* into the École programme. On 24 October 1799, Ingres succeeded as a candidate for admission, working now within the official structure of academic discipline.

pl. 2 Ingres' early success within the École can be seen in an oil study of the male torso, which won first prize in the competition for this category. The painterly handling of the figure, propped by a baton to help steady the pose, already displays a maturity that the École judges were looking for in recompensing student work. It is at once a painting that follows the time-honoured goals in delineating the essentials of anatomy, and at the same time reveals a forceful vigour stripped of academic restraints. How well Ingres consummated both these aspects can be seen here in the palpable naturalism and weight the figure provides, as in the acute understanding of the shadows that delineate the lively form.

In the same year, Ingres thought himself ready to enter the Prix de Rome competition, the most important goal of the École students. Winning the competition afforded the candidate state-subsidised study for up to five years in Rome, where the young painter could become acquainted with the prime material of ancient art, a singular opportunity that otherwise might be closed for less-advantaged students outside the Parisian milieu. Furthermore, every Prix de Rome winner had doors opened, commissions provided, and counted on the experience as the first major step toward a career sanctioned by his peers. Subjects for the competition, always taken from historical and classical literature, were selected by a committee and given to the student in three separate stages. First, a classical subject was provided to be painted as an *esquisse* while the student was sequestered. From these efforts, works were selected to proceed to the second stage, which constituted a nude study from a model posed by the professor and to be completed in four sessions. These in turn were judged with the previous *esquisse*, in which now about eight student works were selected for the final stage. A week later, judges picked the subjects for the candidates, who were given a sheet of paper on which

they were required to make a sketch of the subject in twelve hours, and then from that germ produce a painting in conformity with the sketch that would be judged for the award. Candidates were cloistered for a period of seventy-two days, working every day except Sunday or official holidays on a canvas measuring 113.7 by 146.5 centimetres, called a *toile de 80*. Each of the works was eventually displayed for public viewing—all hung 130 centimetres from the floor—from which the judges then made their final choice. Judges were not required to award the prize, and indeed in some years did not, because they found the quality of the work lacking. It was not uncommon for students who did not succeed at their first attempt to repeat the process for years to come.

When Ingres entered the competition for the first time in 1800, the subject chosen for the final candidates was an episode from Livy, *Antiochus and Scipio*. The prize, however, was given to Jean-Pierre Granger, another student of David's, with Ingres' work (destroyed) receiving second place, an important accolade for a first attempt. If Ingres was discouraged with the results, he hardly mentioned it, applying himself in preparing for the following year's competition. He also continued to work with David, sometimes assisting with the details in his master's work, as indeed he would draw upon students later to assist in his commissions. In March 1801, Ingres advanced to the final stages of the competition easily with a subject taken from the *Iliad*, entitled *Achilles Receiving the Ambassadors of Agamemnon*. On 29 September Ingres' painting pl. 3 was selected for the *grand prix*, a veritable triumph in a painter still only twenty-one years old.

The manner in which Ingres represented the scene was itself extremely clever: he juxtaposed the two parts of the composition so as to compare the opposing forces of war and peace. On the left, the warrior Achilles is shown after having withdrawn from war, his sword and shield virtually hidden inside the tent, as he cultivates the art of music and poetry. At the right, the ambassadors of Agamemnon, led by Ulysses with Phoenix and Ajax, urge Achilles to return to battle, which he refuses to do. Ingres produced a lithesome arrangement between the two camps, with each of the figures responding by gestures and individualistic attitudes. The judges were impressed by the style, manner, and details of the painting—especially the accuracy of the furnishings and the handling of the figures—as they were by the masterful treatment of drapery and setting. While Ingres' composition is purely Davidian, the execution is generally warmer, rooted as much in the veracity of the models he painted so assiduously in his École courses. The colours opt for softer tones, as the control of light and shadow reveals a painter who has clearly mastered these vital areas. When the painting was exhibited in the Salon of 1802, no less a figure than John Flaxman—whose pure outline style had influenced David and would likewise be appreciated by Ingres— thought the painting the most noteworthy he had seen in Paris.

Ingres was unfortunate, however, in not being able to claim his prize immediately because of severe financial strains in the state budget, which impeded his leaving for Italy immediately as was customary. To compensate, Ingres was offered a small stipend and the use of a studio in the former Convent of the Capuchins. It was probably here pl. 4 that Ingres painted his earliest *Self-Portrait*. The present work is different from its original composition because of extensive alterations made before 1851. The original placed Ingres in the same attitude but with his left hand rubbing out a chalk drawing on the canvas, and wearing a grey coat slung over his shoulder. For whatever reasons these modifications were made, the self-portrait reveals the physiognomic features of the twenty-four-year-old painter riding on the success he had already achieved. Assured and comfortable in his role as painter and model, Ingres' portrait displays a clarity and potency that places the viewer within the atelier itself, a visitor who claims the privilege of watching the young master at work, as though he has unexpectedly entered the room.

While Ingres was forced to delay his Roman sojourn, he was given his first official pl. 5 commission, a portrait of Napoleon to be presented to the city of Liège to commemorate the First Consul's act of rebuilding a suburb of the city destroyed in 1794 by Austrian bombardments. As was habitual with Napoleonic portraiture, the Consul had little time to pose, so that Ingres saw Napoleon at Saint-Cloud only once for a fleeting moment. It is therefore even more astonishing that under these constraining circumstances, Ingres was able to evolve an image that exhibits authority and distinction, even if the portrait is hardly a photographic likeness. While it is true that the commission called for an image of benevolence and princely generosity, Ingres nonetheless fashioned a painting that looked forward to many of his later interests. Throughout the portrait, however stiff and unrelenting the model, Ingres infused the interior with gracious details of sensual delight, capturing folds, textures, and substances that caught his eye. From the resplendent gold tassels and the luxurious velvet of the table setting to the rich silk stockings and vivid red uniform of the consul, and even the polished transparency of the diamonds in the sword handle, Ingres loaded the composition with Flemish-like details—appropriate for its destination—that accentuate the inherent beauty of the surface decoration.

Such visual interests on Ingres' part would find further ripeness in a private portrait commission from Philibert Rivière for three members of his family—but curiously minus his son Paul. These would constitute unquestionably Ingres' most gifted works in the genre before his mature style developed in Rome, masterpieces that vie in pl. 6 celebrity with David's prototypical examples. Rivière was an official in the Consulate court whose family possessed great wealth, elements that Ingres wanted to emphasise along with the man's elegance and aristocratic grace. For Ingres, whose portraiture

until now was centred on family friends, accentuating physiognomic verisimilitude but rarely any physical setting, this more formal presentation elicited a somewhat different response. As in the portrait of the First Consul, Ingres opted for a pictorial dimension that would emphasise not only photographic veracity, but would also be a visual essay that probed the polished tastes of the sitter. In this case, Rivière is seated in a sumptuous chair with gold ornamentation, his manicured right hand elegantly jewelled with a superb cameo ring, languorously folded along the lion ornament. The details of the watch-fob, crisp silver buttons, and creamy breeches, reveal a man of sophistication, just as the small still-life at the right, with a print of Raphael's *Madonna of the Chair* casually propped among old books and papers, testify to Rivière's cultural tastes.

No less visually stunning is Ingres' *Portrait of Madame Rivière*, née Marie-Françoise pl. 7 Blot de Beauregard, but known as Sabine, which Picasso so admired. The painting is a veritable poem of arabesque movements rippling through the canvas with magical fluidity. In contrast to its pendant, Ingres' colours are cooler so as to stress the almost lethargic pose, as the accents of beige against blue and red bring out the sensuality of the caressing shawl and limpid veil that cover the extravagant right arm. This pulsating linear abstraction, like undulations of water, is also echoed with subtle brilliance in the portrait of Mlle Rivière, named Caroline, here aged fifteen, who would die the year pl. 8 the portrait was painted. The extraordinary ruffles of the glove that repeat the folds of the dress, the sinuous white boa that envelops and creates a recurrent rhythm, the setting that emphasises her nascent femininity, the physical, almost sculptural presence of the sitter as fragile as porcelain—all of these and more attest to Ingres' visual research in providing portraiture that goes beyond physical likeness. It is perhaps such inventiveness that puzzled critics when these three portraits were exhibited in 1806, as in each of these efforts Ingres at once abided by the conventions of the genre— physical resemblance—while at the same time adding individualistic artistic inventions that challenged the norm.

This is also true for Ingres' portrait of Mme Aymon, known traditionally as *La Belle* pl. 9 *Zélie*, painted in the same year. Compared to the portraits of the Rivière family, this work projects an even more relaxed framework in the fact that it appears more instantaneous and less laboured. The figure, seen bust-length without an interior setting to define the space, appears to lean toward a more Romantic inclination than is evident in his previous work. Many of the features seen in the Rivière portraits are present, but marked especially by the concentration on the coiffure, with its almost sculptural curls accenting the forehead. These circular forms are further highlighted by the delicate, round earrings and the carefully defined strand of pearls, which because of the oval format of the canvas take on beautifully rhythmic

movements. But even more indicative of Ingres' prowess in capturing the beauty and living presence of the model are the large penetrating eyes that confront the viewer directly, as indeed the open mouth creates the sentiment of immediacy that is uncommon in Ingres' work at this time.

The expressive quality of these works reveals Ingres' poetic side in regard to portraiture, but his interest in classical subjects, already developed in David's studio, found an pl. 10 unique idiom at around the same time in his miniature painting *Venus Wounded by Diomedes*. Traditionally dated to the first years of the nineteenth century, the painting relates an episode from Homer's *Iliad* in which Venus implicates herself in the events of the Trojan War and is wounded in the hand by Diomedes. Ingres chose the passage in which Venus is taken to Mount Olympus in the chariot of Isis, while consoled by Mars. What is remarkable in this painting is Ingres' conscious use of an archaic style in which the protagonists are all depicted in profile and with little shading, as if deliberately recalling Greek vase painting. The effect, therefore, is markedly different from the pl. 3 robust *Ambassadors of Agamemnon*, with its detailed modelling of the figures and carefully drawn anatomy and gestures. Without indication of a natural setting or perspective, Ingres drew upon his sense of abstraction to indicate the rarefied realm of the Gods in which the naturalism he employed in his portraits has no place. The image of Venus in particular, with her extended right arm and upwardly inclined head, takes extraordinary artistic liberties which Ingres would repeat throughout his career.

This can already be seen in the commission Ingres received for an image of Napoleon, possibly from the Corps Législatif, although it may well be that the portrait pl. 11 was painted by Ingres on speculation. The resulting work, completed with unusual rapidity, is one of the most authoritative visions of immutable grandeur and political hegemony of the Napoleonic age. By the time Ingres began work, Napoleon had already been named emperor, had crowned himself in pomp and ceremony in the pope's presence in Notre-Dame, and then in May 1805 was proclaimed king of Italy. Although he had suffered defeat in the battle of Trafalgar, this was offset by victories in Austerlitz and then Jena, which reinforced the idea of invulnerable military pl. 5 supremacy. Ingres, therefore, chose a visual schema very different from his first portrait of Napoleon for Liège. Rather than rely on a natural interior setting, Ingres imposed an ethereal province, one that has no rational space, no worldly boundaries, no earthly context. Napoleon sits on a throne worthy of the Gods—indeed indicative of them— surrounded by symbols of strength, history, and tradition that accentuate the lineage and the validity of his position, as seen in the Roman imperial eagle, the Frankish bees gilded on the robe, the sceptre of Charles V, and the hand of justice of Charlemagne. To further add to these attributes, Ingres used several sources to solidify the deistic image, particularly Phidias' lost *Olympian Jupiter* as represented by John Flaxman, and

the imperious figure of God in Van Eyck's central panel of the *Ghent Altarpiece*, which Ingres saw in the Louvre from 1799 to 1816. With these images as sources, Ingres provided an autocratic conception, uncompromising in its frontal rigidity, its pallid colour, and inhuman ethos, rich in opulent details—especially the reflection of the window on the globe—and having a statuesque resplendence that previously had no prototype in French art.

With such prestigious commissions behind him, Ingres thought his position in artistic circles rising, but when most of these works were shown in September at the Salon of 1806, none received critical approbation. Ingres was so stung that he vowed he would never exhibit in the Salon again, a promise he would repeat later. The gist of the criticism was the preponderance of bizarre elements that pointed away from the traditions so insisted upon by conventional guidelines of taste. The linear abstractions in the portraits of the Rivière family were considered odd, the whiteness of Mme Rivière strange, and some of the proportions distorted beyond conventional comprehension. The painting of Napoleon on the throne was criticised even more calamitously as "Gothic", which in this context meant the expression of primitive ideas considered vulgar because they denied the classical model. Among other plaints were the overabundance of drapery that outwardly deflected the lack of perceivable anatomy, or the icy glare of a mummified figure, immobile for want of living matter. One critic even went so far as to suggest that Ingres would do well to go to Italy as soon as possible to immerse himself in the Titians and Correggios that would undeniably rectify these defects. At the time these reproaches appeared, Ingres in fact knew nothing of the reception of his paintings, for he was indeed travelling to Rome, finally claiming the prize he warranted five years before.

INGRES PENSIONNAIRE

"Les matériaux de l'art sont à Florence et les résultats sont à Rome."

After making stops in Milan, Bologna, and Florence, Ingres arrived in Rome on 11 October 1806. The Italian states, not unified until 1861, were still reeling from the tumultuous politics of the Napoleonic Wars. In 1802, the Italian Republic was established and Napoleon was proclaimed its president; in the same year Napoleon annexed Piedmont and Sardinia; three years later, Napoleon was crowned king of Milan and annexed Genoa; Napoleon's brother Joseph was named king of Naples; and then in 1809, the Papal States too were annexed as French territory. In many respects, the Italy in which Ingres was to cultivate his classical spirit was intimately linked to French interests, with special enclaves designed specifically to fulfil state needs. One of

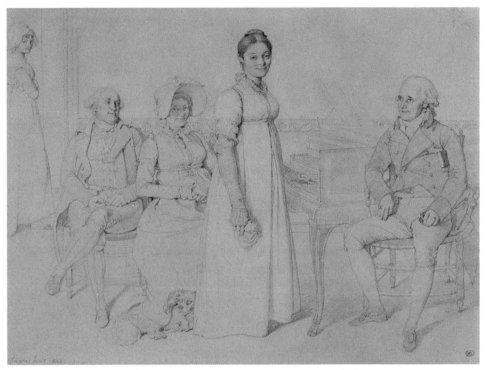

Fig. 1. *The Forestier Family*, 1806, pencil on paper, 23.3 x 31.9 cm, Paris, Musée du Louvre, inv. RF1450.

these, the seat of French artists' sojourns in Rome, was the Villa Medici at Trinità dei Monti, constructed in 1564, and only recently occupied as the Académie de France in Rome. As a resplendent palace with ancient Roman statues, columns, medallions, and a remarkable view of the city, it offered an ideal opportunity for young painters, writers and composers, to absorb Italian aura, tradition, and history.

As a *pensionnaire* of the academy, Ingres was required to live under the strict regulations that governed its inhabitants, including the wearing of uniforms, regular dining hours, and strict work schedules. Absences had to be approved by the director—when Ingres arrived, he was the liberal-minded Joseph-Benoît Suvée, who won the Prix de Rome over David—with travel limited during the first two years to only forty miles outside Rome. Creative requirements were somewhat more lax but still contained certain responsibilities, including specific evidence of their studies in the form of works that were sent to Paris annually, called *envois*. For the first three years of residence, a life-size nude study after the male model formed part of the curriculum, with a copy of a major painting and an invented composition of an historical subject to follow. All of these were eventually exhibited in Paris to monitor student progress and insure that state funds were being spent appropriately.

While there is little information available on Ingres' own thoughts on his first visit to Rome—except an early nostalgia that made him want to return to Paris in the first weeks—Ingres made various studies to provide the Forestier family (to which his fiancée Julie belonged) [fig. 1] with a visual idea of his surroundings. These consist of at least three small paintings on wood that show the neighbouring grounds, which he asked Julie to copy for his father in Montauban—his first landscape painting since his formation under the landscape painter Jean Briant in Toulouse. But the most perceptive of the series of souvenir images is a drawing of the Villa Medici itself, made in early 1807 from Ingres' room in the pavilion of San Gaetano, west of the villa [fig. 2]. The same precision that Ingres displayed in his portrait drawings are visible here, with the equivalent emphasis on topographical accuracy and setting. But here the fundamentals of perspective and panoramic composition require different skills, which clearly Ingres possessed despite his general lack of interest in pure landscape depiction. It is not unlikely that Ingres may have been advised in these works, particularly the drawing, by his friend, the fellow *pensionnaire* Thomas-Charles Naudet, who in Rome was preparing panoramic drawings of this type to illustrate a projected volume of picturesque voyages. It was in fact Naudet, set to leave for Paris in January 1807, who was entrusted to deliver the works for Julie and to discuss the sites he drew and painted in detail.

CONVENTIONS AND CONTRADICTIONS

"Il n'y a pas deux arts, il n'y en a qu'un: c'est celui qui a pour
fondement le beau éternel et naturel."

Among Ingres' tasks in the Villa Medici was to work from the live model, which included females, as many studies from his early notebooks in Rome indicate. This consciousness of the resources of feminine beauty would find pictorial articulation in the first substantial nude Ingres painted, the *Bather of Valpinçon*, so named for one of its pl. 12 owners who purchased it in 1822 for 400 francs. In light of the paintings and drawing that Ingres had worked on previously—chiefly portraiture and Napoleonic commissions—this small, hushed image of an exotic bather in a fantasised oriental setting, devoid of classical trappings, seems decidedly out of step with his earlier classical subjects or portraits. Moreover, compared to the nudes based on ideal stereotyped models, Ingres' painting has a palpability, directness, and sensual delight that is generally absent in the works of his contemporaries. Although the image has been regarded as one of Ingres' finest, the painting was in fact difficult to comprehend according to standards of the day. Seated on a bed whose only support is the finely carved pinpoint of a leg, the bather looks away to the right toward an unknown point,

the direction further augmented by the adept perspective of her right hand. The subtle light and lost profile add to the mystery of the scene, as they also engage the viewer in a quiet dialogue with the formal elements of the painting. The richly brocaded turban—similar to the one Kiki wears in Man Ray's pastiche—is deftly accented by the interplay of the grey drapery at the right and the cool green of the background, as it is equally echoed in the drapery of the left arm, which in turn picks up the fold of the creamy drapes of the bed. It is highly unusual that Ingres would have selected a pose in which the figure is seen from the back, an arresting device, but in doing so he at once draws the spectator into the soundless world his model inhabits, thus rendering an aesthetic meditation on the nude and its poetic possibilities.

Ingres was also required to devise a painting based on a classical or mythological subject. Most of his contemporaries designed works meant to demonstrate an ongoing classical education based on a first-hand examination of the abundant examples of ancient art. A large proportion of these *envois* recalled the stylistic language of the Prix de Rome contest using academic formulas of virtuous heroes conquering improbable obstacles in a style that favoured the ideal and cerebral rather than the individual and the emotional. It was therefore surprising for Ingres' contemporaries to see that the classical painting he was preparing in 1808 as his *envoi* pl. 13 was the undeniably eccentric *Oedipus and the Sphinx*, a subject up to then still rare among painters. At its base, the story, recounted by Aeschylus and Sophocles, revolves around the confrontation of good and evil and the Pyrrhic victory of the former over the latter. Oedipus went to Thebes in search of his parents and encountered the Sphinx, who had ravaged the city when her riddles could not be answered. Ingres depicted the moment of the meeting at the desolate cave where the Sphinx resides, adding a grisly reminder of the bodies of past suitors dramatically at the lower left. Oedipus is conceived as a true classical hero: his body Davidian in its idealism and resolve; the head inquiring and perfect in its proportions; the hand gesturing to underscore the exchange between man and beast. The contrast therefore between the ideal and the horrible, the classical and the repulsive, is all the more expressive as it is odd, an uncanny mixture of the *beau idéal* and Romantic Gothic.

This painting in many ways epitomises the curious direction Ingres was exploring in pl. 3 his early Roman years. Compared to his Prix de Rome entry, with its severity and pl. 13 control, *Oedipus and the Sphinx* is a noticeable step away from the Davidian ideology he employed to win the prize. Compared with the graciously mysterious glow of the pl. 12 *Bather of Valpinçon* painted in the same year, it is difficult to imagine that both works germinated from the same hand at around the same time. When Ingres sent the painting to Paris in October 1808, there were natural misgivings about its composition and unusual blend of styles, and indeed Ingres must have sensed that later when in

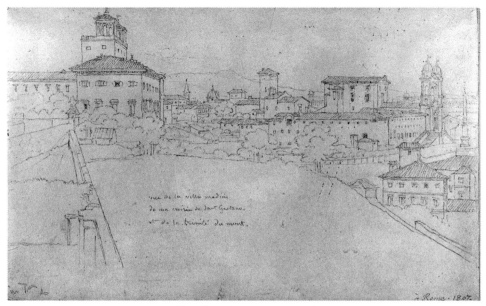

Fig. 2. *View of the Villa Medici, Rome*, 1807, pencil, 12 x 20 cm,
Cambridge, Mass., Harvard University Art Museums, Fogg Art Museum, inv. 1961.9.

1826–27 he added the landscape section at the right to temper the composition. Nevertheless, the painting would in many ways serve as a prototypical image that would inspire others exploring the same theme, from the Symbolists Moreau, Khnoppf, and Redon, to the likes of Francis Bacon.

If such works reveal a contradictory aspect of Ingres' art, the portraits of the period reveal his masterfully inventive side of a genre he began to dislike as inferior to history painting. This can be seen in the first major male portrait Ingres painted in this period, pl. 14 that of his friend François-Marius Granet. Granet too was a student of David who made his debut in 1799, but although never winning the Prix de Rome, he stayed in Rome from 1802 to 1819 with much of his expenses paid by his childhood friend the Comte de Forbin. Ingres and Granet shared little in terms of artistic sensibilities: Granet was grounded in a more romantic aesthetic, which was often expressed in small views of church interiors and cloisters with sharp light sources. But there can be few doubts that Granet's own broadening influence was felt in Ingres' portrait. Unlike those that preceded it, Ingres painted Granet outdoors on the Pincio overlooking the Quirinal Palace with an ominously darkened sky announcing a forthcoming storm. Scholarship is divided on whether Ingres himself painted the landscape or whether it was Granet who supplied it himself. Further romantic elements can be seen in the pose itself, turning inward toward the picture space, which reveals an intense stare, the Byronic overcoat with his high white collar, the wind-tossed hair, and the right hand

holding his own sketchbook. The very attitude suggests an investigation into Granet's character, a physiognomic likeness that discloses an internal spirit as strongly willed as Ingres himself.

In November 1810 Ingres officially completed his requirements at the Villa Medici and had to vacate his rooms. After having worked with Granet in his studio, he rented lodgings at 40 Via Gregoriana nearby, where he would remain for the next nine years. One of his students, Jean Alaux, painted him here in 1818 with his wife Madeleine Chapelle, whom he married in 1813, peering in at the right [fig. 6, p. 104]. The painting shows Ingres in commodious rooms surrounded by his paintings, his violin ready to be played. But before Ingres had achieved the financial means that afforded him this comfort, there were periods of economic strain which he alleviated through dozens of commissioned portraits, many of visiting French and British tourists. Although these are now prized as distinguished examples of his art, Ingres never particularly thought highly of them. They were for him souvenir images made according to the sitter's wishes, little more than a tedious and commonplace manner to alleviate financial difficulties.

Yet, despite Ingres' reluctance to become known as a portrait painter, however great his talents in this area, some of these portraits go well beyond the mundane and reveal the representative finesse and creative imagination that distinguishes many of his foremost efforts. Many of these were of French civil servants and officials in Rome who commissioned Ingres for images as mementos of their years in Rome, as for pl. 15 example his sparkling 1810 portrait of Charles-Marie Marcotte, the inspector general of forests and waterways in Rome. Ingres was chosen for the commission through a mutual friend, a fortuitous circumstance since Marcotte would become a life-long friend and a reliable patron. Marcotte is shown in an undefined interior space, his left arm leaning on a table next to his bicorne with its golden tassel deftly echoing the position of the hand, as he looks toward the viewer with a dour face; the rosette of the Légion d'Honneur was added when Marcotte was awarded the honour in 1836. The restrained manner in which Ingres conceived the portrait is reminiscent of Renaissance works which Ingres was then studying, especially the portraits of pl. 16 Pontormo and Bronzino. These influences can be detected in Ingres' portrait of the Corsican Joseph-Antoine Moltedo, at one time treasurer of the army and then inspector of the mail. In this instance, Ingres opted for a formula closer to his portrait of Granet, positioning the sitter outside against a stormy sky, with the Colosseum seen at the right. Less forbidding that Marcotte, this portrait shows a man of confidence who succeeded not only in his administrative functions, but also in industry. The depiction of his face, with Ingres' remarkably subtle shading, again reveals a forcefully muscular physiognomy, all the more expressive as it is bordered by the high white

collar. If the figure appears unusually squat it is because all of the sides of the canvas were once trimmed for reasons that are not recorded.

While Ingres was working on these portraits and others, he was still required to send another *envoi* to Paris. As a classical subject was obligatory, Ingres chose the story of Jupiter and Thetis, yet a further example of the interplay between male sovereignty and female seduction, in this case to gain favour for the son of Thetis, Achilles. The canvas would be dispatched to Paris at the end of 1811 but not exhibited; pl. 17 Ingres retrieved it later and kept it in his studio until it was purchased by the state in 1835. One might well imagine the reaction this unique image of austerity and voluptuousness on a grand scale must have made. The contrast between an Olympian deity, as gigantic in proportions as awesome in his mien, and the lithesome nymph, forges a incredible visual scenario that deviates substantially from traditional formulas. It is in this painting that one sees Ingres' most audacious liberties in form, as the figure of Thetis, defying anatomical verisimilitude in favour of a highly expressive sensuality that suspends belief as her lissom body, projects her sinuous anatomy upward to Jupiter's throne in a gesture of supplication. But the realm Ingres painted was in the poetic reaches of an Olympian landscape far removed from the naturalism of the real world, the formula he first explored in his *Venus Wounded by Diomedes*. For the image pl. 10 of Jupiter, Ingres certainly referred such diverse visual sources as antique vases and Flaxman's Homeric outlines, all recalling the same austerity and otherworldliness of his equally supernatural representation of Napoleon on the throne. It was Granet who pl. 11 convinced the state to place the painting in his native Aix, but it was not really known to the public at large until Ingres' death.

With the curious picture finished and sent, Ingres was free to concentrate not only on his mainstay of portraits, by which he was making a substantial reputation, but also on important commissions that were on the horizon. Ingres received two commissions in February 1812 for the Palazzo Monte Cavallo, a former papal residence that Napoleon was to occupy in his projected arrival in Rome as a triumphant victor, which his recent defeats annulled. The themes chosen for these were *Romulus, Conqueror of Acron* for Josephine's apartments, and *The Dream of Ossian*, for Napoleon's, two themes of divergent ideologies of southern and northern mythologies. Derived from themes from two of Napoleon's preferred works, Plutarch's *Lives* and the epic poems of the northern bard Ossian, both paintings were intended as large works which necessitated special circumstances in which to produce them, in this case an attributed studio in the tribune of Trinità dei Monti, where Ingres worked on the gigantic *Romulus*.

Of the two, the *Romulus* most adheres to the Academic standards established by pl. 18 David. Ingres followed the text closely, showing Acron defeated and stripped of his

armour at the lower right, while Romulus, wearing the laurel of victory, carries off the spoils of war. The allusion to Napoleonic victories throughout Europe and the *spolia* brought back from the conquered countries—which would arrive by the wagon-full at the Louvre—could not be missed. Ingres too wanted to impart an antique flare in the work, thus aligning the entire scene to echo a procession, while choosing to paint the canvas in pale, almost acrid tempera tones. But however alluring the image, the more ingenious of these commissions was Ingres' ghostly depiction of

pl. 19 *The Dream of Ossian*, intended as a ceiling decoration originally in an oval format. In comparing these two efforts, the two sides of Ingres' artistic personality are manifest: on the one hand, the staunch draughtsman concocting ancient scenes with rigorously applied technique, and on the other, a closet Romantic whose imagination is given a free rein as he enters into the hallucinatory world of the imagination. The poems of Ossian, styled as the Homer of the north, were "discovered" by James Macpherson in 1760–63, endured immense popularity in France, including Napoleon, who read these works avidly. The scene Ingres visualised shows the blind poet Ossian conjuring his creations, represented by Ingres as Fuseli-like forms in an appropriately barren nocturnal landscape of wild sea and craggy rock. His sometimes bizarre Mannerist proportions are still very much in evidence, but this time well appropriated to the magic kingdom of apparitions that convincingly summon the realm of the surreal. That Ingres favoured this work is attested to when, in June 1836, he purchased it back—for 38 *piastres*—and had it shipped to Paris where one of Ingres' pupils transformed it, under his supervision, into a square format and added the warrior at the right.

Within these spheres of the classical and the fantastic, Ingres did not neglect the contemporary. While at the Villa Medici, Ingres made many sketches of the major churches which his friend Marcotte so appreciated that he commissioned Ingres for

pl. 21 the painting *Pope Pius VII in the Sistine Chapel*. Completed sometime the following year, the painting was intended as an example of modern reportage accurately depicting all of the elements that Ingres witnessed, with an almost hyper-realist technique. The painting is an unprecedented record of the interior of the Sistine Chapel that clearly impressed the young Ingres, from the extraordinary power of Michelangelo's *Last Judgement* painted with unerring precision, to the representative frescoes of Rosselli, Botticelli, and Perugino above the papal throne. The sense of accuracy also extended to the figures who assist the pope, all of whom are portraits which Ingres identified for Marcotte in a letter. To add to the souvenir quality of the work intended for a friend, Ingres, with self-effacing humour, included a self-portrait as the fourth train-bearer toward the left.

The importance of Michelangelo's style has been little discussed in the Ingres literature—the preference has always been toward the significance of Raphael—

but an aspect of its importance can be seen in the *Grande Odalisque* painted in 1814. The pl. 20
canvas was commissioned by Queen Caroline of Naples as a pendant to another nude
(lost), but it was left undelivered when the French hold on Naples fell. In this peculiar
image, one of Ingres' most iconic, the painter straddles two different, but related,
pictorial traditions: the Renaissance female Venuses that Titian perfected,
and the sensually Romantic reverie of a harem scene that he already explored in his
Bather of Valpinçon. The luxuriousness of the pose, setting, and detail, as well as the pl. 12
extraordinarily serpentine lines, project a modernity and liberty that is at once striking
as it is unexpected. The linear abstraction that one encounters here in a sense is the
logical conclusion the interrelated design embellishments Ingres used in his portrait of
Mme Rivière more than a decade earlier. But such liberties in anatomy, however pl. 7
intended to express the sinewy, languishing quality of the nude, struck viewers
particularly harshly when the painting was exhibited in Paris in 1819. Critics thought the
painting irrational, awkward, and impossible to decipher in light of the academic nudes
exhibited in the same forum. The undulating movements of the back, so subtly echoed
in the drapery, seemed to most inhuman to the point that critics only saw an anatomy
with too many vertebrae, the right elbow lacking an anatomical joint, or even a lack of
proper musculature to hold the cold flesh in place. Gautier was the exception later,
revelling in the erotic details of the figure, even the unsullied feet, "fresh and white like
camellia buds". But the abstractions Ingres employed were not inconsistent with some
of the Mannerist works of Michelangelo that Ingres observed in Rome and later in
Florence. For Ingres, the precision of photographic reality he imparted in his view of the
Sistine Chapel had no bearing for an image that was at its base a Epicurean exploration
of ideal femininity, a theme to which he returned periodically.

By his own admission, the artistic example that most seduced Ingres was Raphael,
who inspired Ingres to plan a series of paintings relating elements of his biography.
The notion of illustrating the lives of the great masters of the Renaissance had already
taken hold in French painting at the end of the eighteenth century. These paintings
were meant in many instances to be anecdotal narratives, often painted to formulate
visual ideas to the biographical accounts of Renaissance artists then being published.
Ingres painted only two scenes from the history of Raphael, the most important
of which was *Raphael and the Fornarina* portraying his love for a baker's daughter, a pl. 23
scene he repeated in various versions. He placed the scene in Raphael's studio—the
Vatican before its rebuilding by Michelangelo is seen in the window—where the
concentration is placed on the triple interaction between the painter, the model, and
the painting within the painting. Raphael's self-portrait served as the model for
Ingres' version, while the face of the Fornarina comes from a painting by Giulio
Romano, which in Ingres' time was attributed to Raphael. In stressing the attachment
between Raphael and his model, Ingres was individualising the painter who for his

generation was considered divine, and who knew not only the inspiration to perfection Ingres emulated, but was also a painter who personally understood the reality of the beauty he painted.

Ingres' range in historical scenes, particularly related to the French Renaissance, can also be seen in two significant pictures depicting French royalty that Ingres painted for the Comte, later Duc, de Blacas, the French ambassador to Rome. The first, *Henri IV Playing with His Children*, is a curiously unexpected anecdotal account showing the Spanish ambassador at the left visiting the king in his private quarters. Instead of the pomp one might expect of its royal subject, Ingres humanised the first Bourbon king as a devoted father who foregoes the ceremony of such a state visit in favour of playing with his children on the floor of the royal apartments, as the bemused queen and servant at the right look on. The unabashed playfulness of the scene, and the childish amusement seen in the face of the king, shows a side of Ingres' art not yet explored in other works. The lack of solemnity and emphasis on a comic circumstance, while not associated generally with Ingres' art, is very much in evidence. But the technical aspects of the work, especially the veracity of the brilliant costumes, the resplendent fabrics, and the inevitable contrast between the elegant, statuesque figure on the left and the crouching king at the right, again reveals Ingres' capacious imagination.

pl. 25 Even more meaningful in its cultural imagery is *The Death of Leonardo* painted in the following year. The work recounts in a similar manner the history of Leonardo's last years in France after the invitation offered by the first truly French Renaissance king, François I. In selecting a subject such as this, Ingres was recalling not only an important theme that was then common—the lives of the past masters—but he was also paying homage to traditional French encouragement of the arts. François I was a notable admirer of Italian art and had engaged Andrea del Sarto and Benevenuto Cellini, among others, to work for his enlightened court. One of his most innovative acts regarding the enrichment of French art was to bring Leonardo to France, where he was installed in the king's Château d'Amboise on the Loire. Leonardo brought with him the *Mona Lisa*, which is why the painting is the property of the French, but he did not paint while on French soil, occupying himself instead with hydraulic studies. When Leonardo was deteriorating in health, it became legend through Vasari's account that François rushed from Paris to Amboise, arriving just in time for the sixty-seven-year-old painter to die in his arms—the subject of the painting that Ingres reworked in two other variations. Ingres envisioned the scene as a royal homage to artistic genius, a solemn moment when even a great king bows to the apotheosis of art. Ingres' tender gesture of empathy between king and painter stands as an allegorical image of France and the arts of his own day.

pl. 24 (margin reference)

PORTRAITS OF A MASTER

"Les chefs-d'œuvres ne sont pas faits pour éblouir. Ils sont faits pour
persuader, pour convaincre, pour entrer en nous par les pores."

During these years, Ingres suffered immeasurably from a tide of disappointments. His
lack of critical acclaim weighed on him tremendously, making him doubt further the
aesthetic directions he took. The Napoleonic Empire in Italy too was waning, thus
effectively diminishing an important source of patronage. Physical loss also weighed
heavily on Ingres: his father died on 14 March 1814, and Ingres' wife barely recovered
from a difficult pregnancy—the child did not survive—while in 1817 Ingres' mother
too would succumb. In such harsh circumstances, Ingres had no will for large projects,
but his constant need of funds once again fostered the direction of his talents to
portraiture, a genre he began to detest. One of the most lustrous of these was the
portrait of *Madame de Senonnes*, then the mistress of the Vicomte de Senonnes, and the pl. 22
year after the portrait was painted, his wife. There is little doubt that Ingres thought to
exhibit the painting in Paris—but never did—which probably accounted for the
remarkable richness he lavished on the canvas. The sumptuous robe of red velvet, the
delicate lace and gauze around the bodice, the fingered rings and scintillating
necklace, and the enticing use of the mirror, all affirm Ingres' remarkable artistry, even
in a genre he thought less noble that his historical or mythological works.

Many of the portraits Ingres produced in Rome before leaving for Florence in 1819
were of foreigners, who now flocked here after the fall of the Napoleonic Empire in
Italy. Of these, about thirty were British subjects that Ingres drew in pencil for about
40 francs per bust portrait, and slightly more for one of full length. Even if such
drawings were considered by Ingres as no more than prosaic efforts intended to
support his family, his innate talents were such that matters of composition,
physiognomic likeness, and adept handling were always prominent elements. Some of
these pencil portraits were also of distinguished cultural figures, including the
celebrated violinist Niccolò Paganini [fig. 3], who gave a series of public and private
concerts in Rome which Ingres attended. Paganini befriended Ingres after he arrived
Rome in November 1818 and thought so highly of the Ingres' musical abilities that he
asked him to take on the second violin part in private performances of Beethoven's
quartets he had organised during his Roman concert tours. It was perhaps in this
rarefied context that Ingres produced the most iconic portrait of the violinist.

In light of this relentless program of portraiture, Ingres found time to also concentrate
of his historical painting, although before his departure from Rome he completed his
Paolo and Francesca. Given Ingres' roots in classicism, it is surprising that in this pl. 26

instance he relied on Dante, a mainspring of Romantic sensibilities. Taken from Canto V of the *Inferno*, the story relates the illicit love between Francesca, the wife of the repulsive and aptly named Giovanni Malatesta, and his handsome brother Paolo. Ingres depicted the moment after reading tales of the Knights of the Round Table when that love was declared, an instant so pregnant with emotion that Francesca's book is seen dropping to the floor as the pliant Paolo approaches to kiss her. Ingres here has adapted the scene of seduction by reversing the roles he already painted in his pl. 17 *Jupiter and Thetis*, even including the detail of the seducer's extended leg pushing toward the amorous meeting. The concentration of the medieval interior and the abstraction of the figures—not to mention the contrast of emotions between ardour and malice—provides the surprisingly small canvas with an aura of ardour and tragedy that is unique in Ingres' oeuvre. As if to again underscore the relentless inventions of Ingres during this period, it is well to compare his Dantesque scene with Virgil pl. 27 reading from the *Aeneid* of the same year. If Ingres' abstractions in his *Paolo and Francesca* revert to concentrated sensuality, then his *Virgil* returns to the otherworldly pl. 19 fantasies of his *Dream of Ossian*, but here transcribed into the cool iciness of a silently foreboding scene of remarkable restraint.

After completing these works, in June 1819 Ingres accepted an invitation from his friend Lorenzo Bartolini to come to Florence, his first visit here in thirteen years. One of his purposes was to explore new territory after his commissions dried up in Rome and to reawaken his interests in history painting from the frescoes he admired here earlier. But it was still portraiture that Ingres continued to provide in Florence, employing his usual blend of psychological insight and painterly finesse, as can be seen pl. 28 in the portrait he painted of Bartolini. By this time Bartolini was a well-established sculptor whose career was flourishing, an aspect well indicated in the pose of authority and seriousness the sculptor assumes, again recalling attitudes seen in Bronzino's portraits. The still-life details reveal important aspects of the sitter's personality, as indeed they do of Ingres', such as the love of music as emphasised by the violin bow and the statue of Cherubini, thus hinting at the special bonds the two artists enjoyed for years.

In Florence, Ingres remained among a circle of friends who for the most part supported his work with generous por-trait commissions. Many of these were of important figures in the diplomatic corps, whose aristocratic roots called for chilly, pl. 29 formal representations. An apt example of this can be seen in his portrait of Count Gouriev, the Russian ambassador to Rome and Naples. Gouriev was a cultured ambassador who, like many of his colleagues, made the rounds of artists' studios in major Italian cities to enhance his own considerable collection in Russia, favouring the genre pictures of Léopold Robert and Horace Vernet. It is not certain how he came into contact with Ingres, but the portrait the artist produced is one of his most incisive

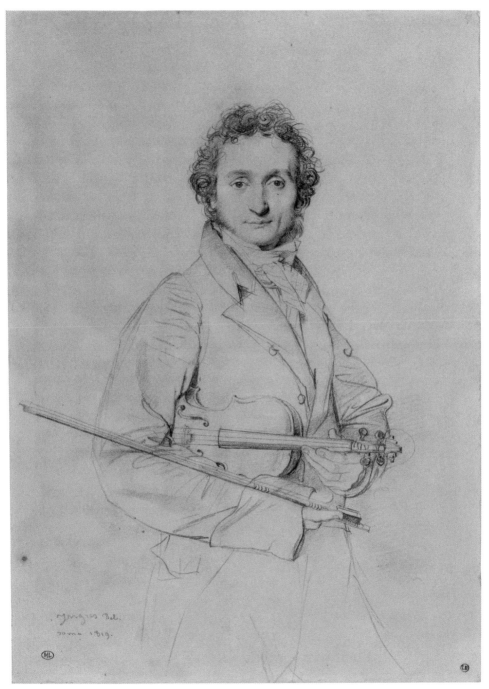

Fig. 3. *Portrait of Paganini*, 1819, pencil on paper, 29.5 x 21.6 cm,
Paris, Musée du Louvre, Département des Arts Graphiques, inv. RF4381.

examples of an arrogant aristocrat. The compositional formula Ingres selected

pl. 14 refers back to his portrait of Granet, where the figure is placed on a loggia with a stormy Tuscan landscape as the backdrop. The severity of the portrait is at once clear, the figure almost unapproachable in his chilly posture. Even the dazzling red of the cape seems to act as a barrier cutting the viewer's distance from the model. The manner in which Ingres painted the count is no doubt an indication of the difficult relationship he must have had with his sitter.

The stark difference between Ingres' portrait of the Russian and those of his friends is stunning, as can be seen in the portrait Ingres painted of Mme François Leblanc two years later. She was the wife

pl. 30 of Jacques-Louis Leblanc [fig. 4], the

Fig. 4. *Portrait of Jacques-Louis Leblanc*, 1823, pencil on paper, 45.7 x 35.5 cm, Paris, Musée du Louvre, inv. RF5642.

secretary to the Grand Duchy of Tuscany, and herself a resident of the Palazzo Pitti as a lady-in-waiting for Napoleon's sister Elisa. Ingres' warm relationship with the family extended well beyond their mutual Florentine sojourn, and indeed the Leblanc family would become a strong supporter of Ingres' work when they returned to Paris in 1833. In this portrait, Ingres relied on a compositional arrangement that clearly recalled the work of his master, David. But here, Ingres was less severe, his brushes radiating in the remarkable accessories, including the stunning gold watch-chain that flows from shoulder to shoulder. If the funereal black dress creates a dark mood for the portrait, Ingres' delicate handling of the lacy, transparent tulle on both arms creates a subtle but dynamic counterpart, as indeed is equally the case with the exquisite contrast of the multicoloured shawl. It is difficult to imagine why the painting was not well received when it was shown in the Salon of 1834, but critics once again decried the lifelessness of the flesh.

The most important commission Ingres received while in Florence was in 1820 when

pl. 31 the Minister of the Interior ordered a painting destined for his native church in Montauban. The subject was fixed as Louis XIII placing France under the protection of the Virgin, an actual event that took place in 1636. The painting would occupy Ingres during his entire Florentine stay, creating difficulties he had not encountered

before because of the necessity to blend an historical portrait and an abstract religious vision within the same composition. Ingres found his solution by relying on the model of Raphael's *Sistine Madonna*, which he had already copied earlier. Juxtaposed in the painting are the elevated kingdom of the Virgin, with befitting clouds, supporting putti, and ethereal light, contrasted with the terrestrial domain of the kneeling king in a church interior. With these references to Renaissance painting, Ingres created a modern version of a time-honoured altarpiece, bringing fantasy, reality, allegory, and symbol into a unified symbiosis.

INGRES TRIUMPHANT

"[L'artiste] ne doit pas se laisser détourner du droit chemin
par le blâme d'une foule ignorante."

After four years in Florence, Ingres left for Paris with the intention of exhibiting this painting in the Salon of 1824. The exhibition scheduled for November would remain one of the most important of the early nineteenth century with its entries by Delacroix and Constable constituting a significant Romantic challenge to the approved aesthetics of classical taste. If in the past Ingres found it difficult to avoid criticisms of "bizzareries", his *Vow of Louis XIII* would win solid support. The painting was signalled as a reminder of traditional artistic values in an arena that saw such violent, heart-throbbing works as Delacroix's *Massacre at Scio*, a steady post in the force of new winds that were gaining ground among radical factions; it is little wonder that Ingres wanted to remove Géricault's *Raft of the Medusa* from the Louvre walls. From his success in 1824, honours began to accumulate: Ingres was named into the Légion d'Honneur by Charles X himself and elected to the Académie des Beaux-Arts, beating Horace Vernet by a single vote. By the end of the following year, Ingres established his studio and began to receive students, an activity he would continue until 1839.

In 1826, Ingres too witnessed the ceremonious installation of his *Vow of Louis XIII* in Montauban where, as an illustrious native son, he received a hero's reception. This rise in status brought Ingres new patronage, especially Amédée-David, Comte de Pastoret, whose portrait he painted in the same year. Pastoret became one of Ingres' pl. 32 most unfailing benefactors, buying and commissioning several important works and trying continually to coax the reluctant painter to provide even more. The portrait is a highly polished example of Ingres' courtly art at its finest, but not displaying the aloofness and coldness of his portrait of Gouriev. The sitter's aristocratic bearing pl. 29 is central to the aesthetic strand of the work, as are the details Ingres laboured over, from the exquisite material of the black coat to the hardness of the gold-and-pearl

sword handle. A measure of Ingres' attention to all aspects of the composition can be seen in the gloves, which Ingres asked the sitter to send him so as to be able to paint them in the studio.

Ingres' increasing stature at this time was underscored by a spectacular commission from the Comte de Forbin, the Director-General of the French museums, for a ceiling decoration to be installed in Room IX of the Galerie Charles X in the Louvre, which would earn him a solid financial base for the first time in his career. pl. 33 Entitled *The Apotheosis of Homer*, the composition is one of Ingres' most severe and symmetrical designs, a gigantic pageant of the continuity of historic classicism. Homer is seen seated at the apex of a slowly rising triangle whose sides are made up of historical figures paying tribute to the source, a visualisation of Ingres' credo that all men who cultivate arts and letters are the children of Homer. Purposely set in a perspective in which the figures achieve grandeur, the scene in fact is a visual encyclopaedia of great men who were inspired by the Homeric tradition, the pillars of western culture: Raphael, Dante, Virgil, Apelles, Aeschylus, Pindar, Molière, Tasso, Shakespeare, Corneille, Poussin, and many more, all vying for prominence in a restrained, intangible space. When the painting was shown in the Salon of 1827, it constituted another unwavering anchor against the Romantic assault as it underscored Ingres' position as the guardian of the most significant traditions in French painting. It was almost certainly in this sense that Degas had himself photographed in 1885 in a pastiche of Ingres' work in which he assumes the role of the surrogate Homer. At the end of 1829 Ingres received his own Homeric reward by being named professor at the École des Beaux-Arts, an accolade that consecrated Ingres' stature in critical opinion. His teaching responsibilities here remained for him an honoured obligation that he took earnestly, working little in terminating his own paintings.

Despite his duties, Ingres found time to create an indisputable masterpiece in his pl. 34 portrait of Louis-François Bertin. Standard-bearer of the *haute-bourgeoisie* that came to power after the July Monarchy, Bertin was the highly influential editor of the *Journal des Débats*. Legend holds that when Bertin sat for Ingres, the painter could not find the pose that best expressed his physical and political immensity. After many frustrating attempts, Ingres supposedly saw Bertin take the effortless attitude he adapted for the portrait while seated at a cafe. The commanding presence of this "Buddha of the bourgeoisie", as Manet famously coined Bertin, is instantaneous and pl. 32 unflagging. Compared to the reserved, manner of the Comte de Pastoret, Bertin's artless informality, an image of his unassuming social rank, makes the picture striking and more immediate. Audiences who saw the portrait in 1833 could not but marvel at how this iconic figure, barely restrained by his coat and vest, reflects an uncontrived presence missing in the more rigid restraints of aristocratic models. The relaxed

judicious monotones highlighted by the strands of silvery hair and a highly polished mahogany chair in which even the reflection of a window can be seen, creates an aura of a living presence, all the more imposing in its frank lack of expected sophistication.

But however important Ingres' triumphs in these years, critical acclaim was not immutable. This denigration reached a peak with Ingres' painting *The Martyrdom of* pl. 35 *Saint Symphorian*, a commission for the decoration of the cathedral of Autun first given to Ingres a decade before and shown in the Salon of 1834. Never wholly at home in pure religious painting, Ingres tried to resolve the compositional and emotional perplexities of an ancient scene of martyrdom in a crowded tableau with the saint in the centre. Dozens of studies verify Ingres' difficulties in finding the visual approach for this gigantic work, which explains the inordinate length of time Ingres took to complete it. Two important painted *esquisses* testify to Ingres' remarkable pls. 36, 37 research in finding the right poses, attitudes, expressions, and other elements of the composition. But despite an enormous amount of work on the canvas, critical reaction when it was shown was almost universally negative as ineffectual and retrograde. Ingres was so shaken by this harsh reaction that he vowed never to show in the Salon afterwards. Frustrated by the vagaries of current art criticism, Ingres sought to leave Paris by taking advantage of the vacancy of the director of the Académie de France in Rome. When he arrived there in January 1835 for a six-year term, he took with him a silver cup that his students presented him as a gesture of their *amitié*.

THE PENSIONNAIRE AS DIRECTEUR

"Adressez-vous donc aux maîtres. Parlez-leur, ils vous répondront,
car ils sont encore vivants."

It is not wholly accurate to view this phase of Ingres' career as only a revolt against boorish criticism. For a decade, Ingres had been in the limelight, had many important commissions, and found his teaching duties at the École highly satisfying. As the head of France's premier institution in Rome, Ingres in effect reached an artistic pinnacle which gave him undisputed power in forming a new generation of pupils. But Ingres found the Villa Medici programmes wanting as an institution at this time and set out to revitalise them. He added important courses, including the first in archaeology, made many renovations to the building, enlarged the library, and expanded the plaster cast collection while overseeing the artistic education of new students. Many accounts document that as director, Ingres was extremely tolerant of different approaches to painting—in contrast to notions of his autocratic rule—and that his aid to students was ceaselessly unstinting. Visitors found his door open; painters and composers in

residence were often invited for tea and discussion. While his reign was a satisfying reprieve from the anxieties of Paris, Ingres nevertheless had to wage constant administrative battles over diminishing funds, papal approval, and manage an institution during a devastating cholera epidemic that killed 300 Romans per day. Ingres was so immersed in his responsibilities that he barely touched crayon or brush for the first three years of his tenure.

In his new situation, Ingres turned once again to portraiture, but this time in the form of small drawings, which he produced for pleasure rather than for financial necessity. These *portraits intimes* took on a new personal weight as a separate artistic manifestation in which he recorded close friends to whom he often gave the sketches, distinct records of a special camaraderie with cherished supporters or admired individuals. In his second Roman stay, he produced no fewer than twenty-three of these, all of them with the same care as in his paid commissions. As earlier, many of these were of friends from the cultural world, particularly musicians with whom Ingres always maintained warm relations. It was in this context that in January 1839 Ingres met Franz Liszt, then only twenty-seven years old, who had already begun a brilliant career as a flamboyant pianist, very much influenced by the pyrotechnics of Paganini, whom he had seen in Paris. Liszt also possessed a wide cultural background which permitted him to converse with Ingres on Michelangelo and Raphael, as well as on Dante and Goethe. Their common interests produced lively entertainment, including performances of works for piano and violin by Mozart and Beethoven. When Liszt left Rome in May, Ingres gave the composer's mistress one of the most perceptive portraits of the pianist ever made, a beautifully crafted image adroitly highlighted in white along the shirt collar and forehead. That Liszt always treasured his relationship with Ingres is attested to in correspondence and gifts he sent to Ingres, including his piano transcriptions of Beethoven's symphonies. Two decades later Liszt's daughter Cosima—Richard Wagner's wife—was advised to purchase one of Ingres' paintings that had come on the market.

Another musician who struck up an enduring relationship with Ingres was Charles Gounod, winner of the Prix de Rome in music in 1839. Ingres had already known Gounod's father, a competent if uninspiring painter, and now, as director, could help guide the son as a personal protégé. Gounod and Ingres also had another common link in that Gounod's prize-wining composition for the Prix de Rome competition pl. 32 was a cantata whose text was composed by the Comte de Pastoret. Ingres knew too that the young Gounod had inherited some of his father's visual talents and therefore had him copy more than a hundred engravings after antique works. Ingres and Gounod saw each other regularly outside of the Academy programmes each Sunday evening in the salon of the villa, talking, singing, and playing music together, especially Mozart and Gluck whom they both adored.

Of the paintings that Ingres was able to complete in Rome, despite persistent attacks of rheumatism, two stand out as further demonstrations of the opposing directions of his art, the sensually exotic and the cerebral classical. The justly famous *Odalisque* pl. 38 *with a Slave*, commissioned by Marcotte long before its completion in 1839, reverts to the earlier beguiling fantasies of the orient that remained in Ingres' eye for years to come. The painting is a jewel-box composition appealing to all of the five senses, a rhythmic exploration of lethargic beauty in which decorative patterns, not unlike a Persian miniature, define the undulating surface. The nude, having just finished smoking her hookah, drowsily listens to the plaintive music played by the slave as she further falls into an opiate dream. Much of the painting was done while Ingres was ensconced his rooms during the cholera epidemic which prohibited the use of outside models, forcing him to invent the scene from existing drawings and his romantic imagination.

His *Antiochus and Stratonice*, on the other hand, occupies another artistic sphere. Few of pl. 39 Ingres' efforts gave him as many pains as did this painting commissioned by the Duc d'Orléans in 1833 on a subject from Plutarch. The story relates Antiochus' undefined illness, which is later diagnosed as the result of his love for his stepmother. Having already made sketches for the work in Paris, Ingres abandoned these in Rome and began to devise new ideas, using his wife, friends, and even himself as models. The results show a hermetic setting like the one in his *Odalisque*, lacquered with the same refinement and precision, as the physician Erisistratus realises the cause of the illness in the isolated, statue-like figure of Stratonice. As this painting was to be his first new picture to be shown in Paris since the debacle of 1834, Ingres' anxieties were especially high. After having sent the picture, Ingres' term as director was terminating; on 6 April 1841, he made his farewells to the Villa Medici and by May was again in Paris. He learned from Granet that the picture was in fact well received and his reputation wholly intact.

M. INGRES, "SOVEREIGN PONTIFF OF MODERN ART"

"Je compte beaucoup sur ma vieillesse: elle me vengera."

Ingres' return, prepared by dozens of friends, was a ceremonious affair. Ingres was fêted repeatedly, on one occasion with more than 400 guests presided over by Pastoret, who also arranged a concert organised by Hector Berlioz. He met Louis-Phillipe, enjoyed the adulation of friends, and was awash with commissions including one from the king for seventeen stained-glass window designs for a chapel dedicated to the recently deceased Duc d'Orléans. He would also attend to a sumptuous commission from the Duc de Luynes for work at his chateau at Dampierre which, despite enormous effort,

would never be finalised although many sketches remain [fig. 5]. But from the
pl. 40 immediate demands, Ingres first completed a portrait of his beloved Cherubini, which
he had begun about 1834. He had taken the initial portrait with him to Rome, but
altered it substantially afterwards, using Gounod as a model for the body and hands; he
also added the Muse Terpischore at the right, thus transforming the portrait into a
veritable apotheosis. This time Ingres did not exhibit the painting in the Salon but
rather in his studio, where it was extremely well received, including by Cherubini,
who in gratitude wrote a small cantata in Ingres' honour. When Cherubini died in
March 1842, the king purchased the canvas to install it in the Musée de Luxembourg,
only the second painting by Ingres on permanent public display in Paris.

Despite such accolades, the bulk of Ingres' Parisian commissions remained embedded
in portraiture. He repeatedly wrote of his disdain for the genre and even had the
courage to refuse many prominent offers. But certain requests were inescapable,
particularly those from some of the wealthiest families in Paris to whom he had
to cater. Such an example was the portrait of the Comtesse d'Haussonville, the
pl. 41 daughter of the Duc de Broglie and rebellious granddaughter of Mme de Staël.
The chronology of the painting is complex, with Ingres having serious difficulties in
finding the pose, or having the sitter available to him without interruptions. Because
Ingres knew his painting was intended for an important client with great influence, he
spent an inordinate amount of time in devising all aspects of the picture; the model
herself once referred to Ingres' perpetual slowness when he took nine days alone to
work on one of the hands. This fastidiousness is apparent in the exceptionally rich
handling of the picture, from the thoughtful yet coquettish pose of the model in a
luxurious silk robe, to the setting in the salon of the d'Haussonville estate, with its
large mirror and armchairs that border each corner. The carefully placed objects of the
mantelpiece, in effect almost a separate still-life arrangement of flowers, Sèvres
pottery, opera glasses, and calling cards, are nothing less than a tour-de-force of
illusionist painting. And yet, despite the remarkable beauty of the portrait, Ingres
wrote when it was finished in June 1845, that he considered it a disastrous effort that
had tormented him for years.

The following year was a crucial one for Ingres. For the first time, an important
selection of his works in various genres would be seen by the public on the boulevard
Bonnes-Nouvelles in a charity exhibition to help needy artists. Ingres agreed because
of the altruistic cause, contributing eleven paintings, separated from the others in an
alcove. This restrained retrospective represented works that ranged in date from the
pl. 13 *Oedipus and the Sphinx* of 1808 to the d'Haussonville portrait almost four decades
later. Critical response was largely positive: Paul Mantz called Ingres, "the sovereign
pontiff of modern art", an epithet that even Baudelaire did not argue with, marking

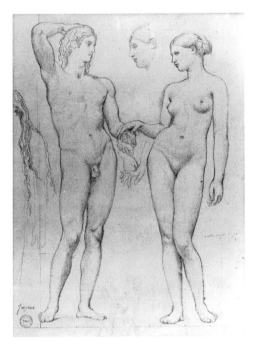

Fig. 5. *Studies for "The Golden Age"*, ca. 1842, pencil on paper, 41.6 x 31.5 cm, Cambridge, Mass., Harvard University Art Museums, Fogg Art Museum, inv. 1943.861.

this representation "the entire Genesis of his genius". But even as Ingres was so acclaimed, he went through a period of depression that culminated when his wife died in July 1849. He moved to different lodgings, travelled to alleviate his pain, and definitively abandoned the commission at Dampierre, for which he was to be paid a fortune. In the autumn of 1850 when he was seventy, Ingres, concerned over the future of his works, sent almost fifty examples from his collection to Montauban, the seed for the Musée Ingres that would be added to periodically. In 1851 Ingres also concluded his association with the École des Beaux-Arts, when he resigned from his post as professor.

Although now even more independent, Ingres sought to complete several important commissions, including the portrait of *Mme Moitessier*. The idea was first approached by the faithful Marcotte in pl. 42 1844, but Ingres initially refused and then changed his mind after he was seduced by the beauty and allure of the model. In the following dozen years, Ingres would make a second portrait of her, this time seated, which had an extremely troubled history, a pl. 43 further example of Ingres' constant striving for ideas: the portrait was drawn in 1847, sketched on the canvas in 1848, abandoned the following year, resumed in 1852, abandoned again the following year, resumed again in 1854, and then completed almost three years later. Both portraits are exceptionally engaging images, ripe with Ingres' customary richness in colour, surfaces, and plentiful details, as they are expressions of the character of the matronly model. However dazzling both portraits are, Ingres anguished over them to the point that he referred to both as "these nightmares".

In between these two versions of Mme Moitessier, Ingres painted her sister-in-law, pl. 44 Princess Albert de Broglie, one of the last great portraits from his brush. Ingres had his perpetual troubles and fears while working on the commission, suffering from serious eye strain while sketching directly in the de Broglie household. In this instance, Ingres reduced the background to a minimum in order to highlight the opulent model in

her shimmering silk taffeta robe that competes with the sensuous yellow surface of the chair. Few portraits of the nineteenth century, including Ingres' best work in the genre, could rival the radiance of the portrait or its impressive elegance, including the jewellery, soft lace, and breathtaking rendition of textures. The face too has a delicate warmth and tranquil composure that is unparalleled, a vital presence that would be extinguished by her death only seven years later. Unlike his previous portraits of the period, Ingres conceded that the portrait was "truly beautiful", an opinion shared by critics when they saw the portrait in 1855.

The occasion was the unique circumstance of the Exposition Universelle in which four artists—Ingres, Delacroix, Vernet, and Descamps—were honoured by individual retrospectives, for which each painter selected the works they wanted shown. Ingres' exhibition contained forty-three canvases spanning his entire career, some of which were criticised as they had been before, but not his portraits, which persistently evoked rapturous responses. At this point Ingres had nothing more to prove and was less wounded by these adverse remarks, but with old age he became even more recluse, while still accumulating honours, including the appointment of Sénateur by Napoleon III. He no longer showed any works in public as he continued to pursue prized projects that he had either abandoned, or with which he never was fully content.

One of these was centred around the figure of Joan of Arc, whom he drew in 1844 as an illustration for a book on the lives of great figures from the history of France. The occasion to rework the story, which became a steady source of illustration in Paris at this time, was a commission in 1851 for two paintings from the director of the Beaux-Arts for a stately sum of 20,000 francs. Ingres' original drawing was of the single figure of Joan of Arc, which Ingres represented while attending the coronation of Charles VII in 1429 after the siege of Orléans. When Ingres was painting the figure, he added the praying monk (Jean Paquerel), the servant at the left (Doloy), pl. 45 and the kneeling pages. These created a more dense composition that helped accent the interior space and the piety of the scene. Ingres' concern here was in effect to depict a historical episode, but it is clear that he was also enchanted by the medieval accessories that provide sparkling details of medieval Christianity. To add to the devout mood of adoration, Ingres included his own features for the portrait of the pl. 31 equerry, thus, as in his *Vow of Louis XIII*, blending the abstract with the modern.

To the modern eye, such pictorial translations of medieval iconography might appear stilted, or perhaps already anachronistic at a time when artistic transformations were imposing themselves on the Parisian art world. When Ingres painted his *Joan of Arc*, Gustave Courbet had already completed his ground-breaking canvas *The Stone*

Breakers and was working on his gigantic "real allegory" that would become a spiritual autobiography as envisioned in his studio. But for Ingres, the timelessness of his subjects and technique was primary, a direct link with the great masters of the past that he felt should be the foundation for art. It was this continuity of tradition that formed the basis of Ingres' artistic philosophy and propelled him in his last years to work in this vein. This is the case with *La Source*, on which Ingres worked pl. 46 intermittently since the 1820s. The allegorical nude, budding with youthfulness as she embodies the sentiment of rejuvenation, represents a further example of Ingres' persistent search for ideal feminine beauty, a bond he shared with such aesthetic mentors as Raphael and Titian.

In his old age Ingres produced two works meant to be understood as tentative tributes to his long career. One of these was a self-portrait that he painted when he was pl. 48 seventy-eight years old. The work had been talked about as early as 1839, when Ingres was asked to contribute his image to the prestigious gallery of artists' portraits in the Uffizi. Ingres' duties at the Villa Medici prevented him from accepting, but when he was asked again in 1855, he was ready to oblige. When it was completed three years later, Ingres explained that it was purposefully painted in a simple manner so that it would not take away from the other portraits in that terrestrial Pantheon of great painters. In this light, it is worth noting that Ingres did not include any visible indication of his status as a painter, but rather insisted on representing himself as a *grand bourgeois*, with only the rosette of a grand officer of the Légion d'Honneur to mark the honours he bore. There is no hint of dandyism either, nor of exceptional pride, nor the marks of his advanced age, not even a strand of grey hair.

Ingres continued to draw in the late 1850s and 1860s, showing that his talents never diminished, but only one new creative effort came from his brush, a kind of *summa* of the artist's ceaseless search for Raphaelesque beauty. Completed in 1863, the year as the infamous Salon des Refusés, his *Turkish Bath* represents the last, clearly erotic, pl. 47 fantasy of a painter whose idealism, even when shackled to portraiture, never fully abandoned him. The motif is nothing less than a symphonic arrangement of feminine voluptuousness in which twenty-five figures are cramped into an oval design hermetically sealed from the real world. Attitudes and poses already used earlier were visually rephrased into this new context of a daydream seraglio in which the stimulating softness of all the senses are intensely aroused: incense is burned, a mandolin plays, coffee is sipped, breasts are fondled. Again, Ingres took great liberties with anatomy, line, and space to pack this singular work with expressions—rather than demonstrations—of imperishable beauty. If it was difficult in Ingres' time to comprehend this epic of sensual indulgence, it was even more problematic six decades later for Paul Claudel, who described the canvas as "a mass of women stuck to one

another like a cake of maggots". Even his last private canvas could not escape criticism, although again his aesthetic heir Picasso would spin dozens of variations on the theme.

Ingres was eighty-three when he executed this painting, and knew it would be his last. In 1866 he drew up a will that bequeathed much of his collection of paintings, drawings—more than 4,000 of them—manuscripts, antiquities, engravings, and musical scores to Montauban, where they remain. He also made personal gifts to favoured friends and patrons, and provided for his second wife, Delphine Ramel, a relative of Marcotte, and whom he married in 1852 when he was past seventy. On the morning of 8 January 1867, Ingres touched his pencils for the last time, tracing a print of Giotto's *Christ at the Tomb* from the Arena Chapel, a befitting return to the *primitifs* he so admired. The afternoon was taken up with a musical recital, during which Ingres caught a chill that degenerated into pneumonia. Six days later, at one in the morning, Ingres died in his apartments at 11 Quai de Voltaire.

LIST OF PLATES

pl. 1. *Portrait of A Man*, 1796, graphite on parchment, with black ink and green watercolour, 13.7 cm, Washington, D.C., National Gallery of Art, Rosenwald Collection, inv. 1954.12.82.
The identity of the man is not known, but the complete signature within the inner band, "ingres fils. f. 13 [7]ᵇʳᵉ 1796", is unquestionably in the artist's hand when he was sixteen years old.

pl. 2. *Male Torso*, ca. 1800, oil on canvas, 102 x 80 cm, Paris, École Nationale Supérieure des Beaux-Arts, inv. 15
Painted while in David's studio, this *académie* is a typical example of the type of oil studies that pupils were required to paint from the live model; it won for Ingres the Prix de Torse (half-length) on 2 February 1801 at the École des Beaux-Arts.

pl. 3. *Achilles Receiving the Ambassadors of Agamemnon*, 1801, oil on canvas, 113 x 146 cm, Paris, École Nationale Supérieure des Beaux-Arts, inv. PRP 40.
This painting was the second entry Ingres painted for the coveted Prix de Rome contest. In a purely classical style that shows the teachings of David, it was awarded the *grand prix* on 29 September 1801.

pl. 4. *Self-Portrait*, 1804, oil on canvas, 77 x 63 cm, Chantilly, Musée Condé, inv. PE 430.
When the painting was exhibited in the Salon of 1806, it was in a different state, with the left hand rubbing out a drawings in chalk on a canvas; Ingres reworked it before 1851, placing the left hand on his breast. The painting was given to Prince Napoleon in exchange for the *Turkish Bath* [see pl. 47].

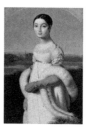

pl. 5. *Bonaparte as First Consul*, 1804, oil on canvas, 227 x 147 cm, Liège, Musée d'Art Moderne et d'Art Contemporain, on loan to the Musée d'Armes, Liège.
The painting was commissioned by Napoleon on 29 Messidor, year XI (17 July 1803) for the city of Liège, where the First Consul had donated funds to rebuild a neighbourhood destroyed by Austrian artillery in 1794; Ingres was paid 3,000 francs. The portrait was unveiled in Liège on 25 May 1805.

pl. 6. *Portrait of Philibert Rivière*, 1805, oil on canvas, 116 x 89 cm, Paris, Musée du Louvre, inv. MI 1445.
The commission for portraits of the Rivière family—see pls.7 and 8—came to Ingres through Philibert Rivière, a court official under the Empire. All three portraits were exhibited in 1806 and remained in the family until they were bequeathed to the state in 1870.

pl. 7. *Portrait of Madame Rivière*, 1805, oil on canvas, 116.5 x 81.7 cm, Paris, Musée du Louvre, inv. MI 1446.
She was Marie-Françoise-Jacquette-Bibiane Blot de Beauregard (1773–1848), and outlived her husband by 38 years.

pl. 8. *Portrait of Caroline Rivière*, 1805, oil on canvas, 100 x 70 cm, Paris, Musée du Louvre, inv. MI 1447.
The daughter, Caroline, is represented when she was 15 years old; she would die in the same year that Ingres finished the portrait. In his notebooks, Ingres spoke of the "ravishing daughter" of the Rivières.

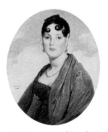

pl. 9. *Portrait of Madame Aymon ("La Belle Zélie")*, 1806, oil on canvas, 59 x 49 cm, Rouen, Musée des Beaux-Arts, inv. 870.1.1.
Nothing is known about the model or the circumstances in which Ingres painted the portrait. The painting first appeared only in 1857; the appellation "La Belle Zélie" refers to a popular song on the 1870s. It is signed and dated and was donated to the town of Rouen by M. Féral-Cussac in 1870.

pl. 10. *Venus Wounded by Diomedes*, ca. 1800-6, oil on canvas, 26.5 x 33 cm, Basel, Kunstmuseum, inv. G 1977.38
There is little consensus on the actual date of the work, but it is generally agreed that it was meant as a study for a larger work that apparently Ingres never painted.

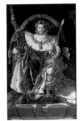

pl. 11. *Napoleon I on the Imperial Throne*, 1806, oil on canvas, 259 x 162 cm, Paris, Musée de l'Armée, Palais des Invalides, inv. 5420.
Probably commissioned by the Corps Législatif, the painting has always been considered an example of Ingres' "Gothic" style. When it was shown in the Salon of 1806, it was puzzling to most critics because of its harsh, frozen manner. It was nevertheless acquired by the Corps Législatif in August 1806, and transferred to the Louvre before 1815.

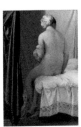

pl. 12. *The Bather of Valpinçon*, 1808, oil on canvas, 146 x 97.5 cm, Paris, Musée du Louvre, inv. RF 259.
The painting was executed in Rome and sent by Ingres to the Fine Arts class of the Institut de France in the year it was completed. Ingres sold the painting through the intermediary of the painter Gérard; in 1822 it was again sold to Valpinçon from where it received its title, and it entered the Louvre in 1879.

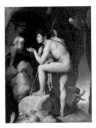

pl. 13. *Oedipus and the Sphinx*, 1808, oil on canvas, 189 x 144 cm, Paris, Musée du Louvre, inv. RF 218.
Painted as one of Ingres' *envois* from the Villa Medici, the work was first exhibited there after its completion before Ingres sent it to Paris. After it was shown in the Salon of 1827, Ingres enlarged the scene, particularly the section at the right.

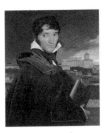

pl. 14. *Portrait of François-Marius Granet*, ca. 1807–08, oil on canvas, 74.5 x 63.2 cm, Aix-en-Provence, Musée Granet.
The portrait is of the painter Granet (1775–1849), whom Ingres met in Rome; the sitter is posed on the Pincio overlooking the Quirinal at the right. It remained in Granet's collection until 1849 when he bequeathed it to Aix-en-Provence.

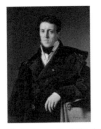

pl. 15. *Portrait of Charles-Marie Marcotte d'Argenteuil*, 1810, oil on canvas, 93.7 x 69.4 cm, Washington, D. C., National Gallery of Art, Samuel H. Kress Collection, inv. 1952.2.24.
Marcotte (1773–1864), the director of forests and waterways in Rome, was one of Ingres' most faithful friends and patrons. He was recommended to Ingres for his portrait by a mutual friend, Édouard Gatteaux, who himself had won a Prix de Rome award.

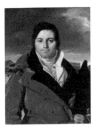

pl. 16. *Portrait of Joseph-Antoine Moltedo*, ca. 1810, oil on canvas, 75.3 x 58.1 cm, New York, The Metropolitan Museum of Art, H. O. Havemeyer Collection Bequest of Mrs H. O. Havemeyer, 1929, inv. 29.100.23.
He is the Corsican official who between 1803 and 1814 was the director of the Post Office in Rome; shown against a background of the Colosseum and the Appian Way, the portrait was one of several Ingres painted of French officials in government service. The painting once belonged to the critic and friend of Manet, Théodore Duret.

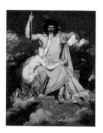

pl. 17. *Jupiter and Thetis*, 1811, oil on canvas, 327 x 260 cm, Aix-en-Provence, Musée Granet. This was the last painting Ingres sent from Rome as a *pensionnaire* at the Villa Medici; it was never shown in the Salons, and remained in Ingres' possession until it was purchased by the State in 1835. It was shortly afterwards sent to Aix-en-Provence in exchange for a painting by Gros.

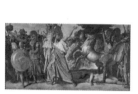

pl. 18. *Romulus, Conqueror of Acron*, 1812, tempera on canvas, 276 x 530 cm, Paris, Musée du Louvre, inv. DL 1969-2. The work was commissioned in 1811, along with the next pl. 19, by the Administration Impériale to decorate the second salon for the empress in the Palazzo Monte Cavallo, now the Quirinal Palace. One of Ingres' largest paintings, it was appropriated by Pope Pius IX, who gave it to Napoleon III in 1867.

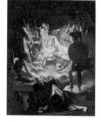

pl. 19. *The Dream of Ossian*, 1813, oil on canvas, 348 x 275 cm, Montauban, Musée Ingres, inv. MI 867.70. The work was commissioned as a pendant ceiling decoration for Napoleon's bedroom in the Quirinal Palace, which he never inhabited. It was taken down about two years later and not heard of until 1836 when, in bad physical condition, Ingres bought the painting back. He intended to transform it into a more rectangular composition, and asked his student Balze to help him.

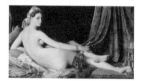

pl. 20. *La Grande Odalisque*, 1814, oil on canvas, 91 x 162 cm, Paris, Musée du Louvre, inv. RF 1158. The painting was commissioned by Caroline Murat, queen of Naples, as a companion piece for another reclining nude figure by Ingres in her collection. However, with the fall of the Napoleonic Empire in Italy, the painting was never delivered. It was sold several years later to James de Pourtalès-Gorgier, chamberlain to the king of Prussia and did not enter the Louvre until 1899.

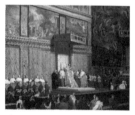

pl. 21. *Pope Pius VII in the Sistine Chapel*, 1814, oil on canvas, 74.5 x 92.7 cm, Washington, D. C., National Gallery of Art, Samuel H. Kress Collection, inv. 1952.2.23. The painting was commissioned by Charles Marcotte [see pl. 15]. The pope at the time had been a virtual prisoner after Napoleon annexed the Papal States. When the painting was exhibited in Paris, however, Napoleon had been defeated and the pope restored to his throne. Ingres' self-portrait appears on the left. The painting bears the date of "1810" at the lower right, but this was due to a false restoration after the original date had been erased.

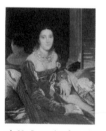

pl. 22. *Portrait of Madame de Senonnes*, ca. 1814–16, oil on canvas, 106 x 84 cm, Nantes, Musée des Beaux-Arts, inv. 1028. Born Marie-Geneviève-Marguerite Marcoz, she married Vicomte Alexandre de Senonnes, later Secretary-General of the Musées Royaux, in Rome in 1815. Acquired in 1853, the painting was one of the few by Ingres that was sold to a public museum outside Paris in the his lifetime.

pl. 23. *Raphael and the Fornarina*, ca. 1814, oil on canvas, 64.7 x 53.3 cm, Cambridge, Mass., Harvard University Art Museums, Fogg Art Museum, Grenville L. Winthrop Bequest, inv. 1943.252. This one of several versions of the theme that Ingres painted in Rome, as is indicated in an inscription in Ingres' hand on the lower left. This version, exhibited in the Salon of 1814, too was purchased, and possibly commissioned, by de Pourtalès-Gorgier [see pl. 20] before being sold to the Rothschild family, who then sold it to Grenville Winthrop.

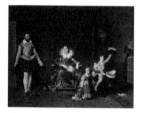

pl. 24. *Henry IV Playing with His Children*, 1817, oil on canvas, 39.5 x 50 cm, Paris, Musée du Petit Palais, inv. Dut. 1164. The painting and its pendant [see next plate] were commissioned by the Comte, later Duc de Blacas, the French ambassador to Naples and then to Rome. Exhibited in the Salon of 1824, the painting, like its pendant, was considered lost but was in the collection of the marquise de Virieu, née Blacas, until it was purchased by the state in 1968.

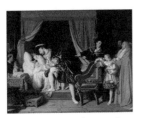

pl. 25. *The Death of Leonardo*, 1818, oil on canvas, 40 x 50.5 cm, Paris, Musée du Petit Palais, inv. Dut. 1165.
As a pendant to pl. 24, the painting shows another aspect of French history, this time stressing its long record of encouragement of the arts when François I invited Leonardo da Vinci to France.

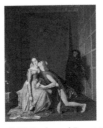

pl. 26. *Paolo and Francesca*, 1819, oil on canvas, 47.9 x 39.3 cm, Angers, Musée des Beaux-Arts.
The subject was from Dante's *Inferno* (Canto V) which depicts the famed thirteenth-century lovers in the Second Circle of Hell. Ingres made several paintings of the story, of which this one was painted in Rome after his first study five years earlier. It was sold to the Société des Amis des Arts in 1819, and purchased there by Turpin de Crissé who bequeathed it—along with all his own works— to the city of Angers.

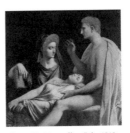

pl. 27. *Tu Marcellus Eris*, 1819, oil on canvas, 138 x 142 cm, Brussels, Musées Royaux des Beaux-Arts, inv. 1836.
The work had a troubled history, having been commissioned first in 1811 by General Miollis for the Villa Aldobrandi in Rome, where it was titled *Virgil Reading the Sixth Book of the Aeneid to Augusta*. This version, with the present title, was reduced to three figures—Augustus, Livia, and Octavia—without decorative trappings.

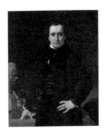

pl. 28. *Portrait of Lorenzo Bartolini, 1820*, oil on canvas, 108 x 85.7 cm, Paris, Musée du Louvre, inv. RF 1942-24.
Ingres had met the sculptor Bartolini in Paris, where the two shared a studio; when Bartolini moved to Florence in 1814, he asked Ingres to stay with him, acting as his intermediary in Florentine society. Ingres thought Bartolini "the greatest sculptor of the century".

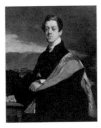

pl. 29. *Portrait of Count Nicolas de Gouriev*, 1821, oil on canvas, 107 x 86 cm, Saint Petersburg, The State Hermitage Museum, Naryshinka Collection, inv. 5678.
The count, known in Russian as Nicolay Guryev (1792–1849), fought against Napoleon in 1812; he was in the diplomatic corps in Italy from 1821 where, while in Florence, he had this portrait painted. The background, however, shows the town of Palombara Sabina near Tivoli.

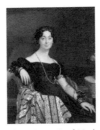

pl. 30. *Portrait of Madame Jacques-Louis Leblanc*, 1823, oil on canvas, 119.4 x 92.7 cm, New York, The Metropolitan Museum of Art, Catherine Lorillard Wolfe Collection Wolfe Fund, 1918, inv. 19.77.2.
The portrait of Mme Leblanc, née Françoise Poncelle, was painted in Florence and is inscribed at the lower left "Ingres P. flor. 1823". Ingres made more than two dozen sketches for the work before he settled on the pose seen here. The painting was exhibited singly—without the pendant portrait of her husband— in the Salon of 1834.

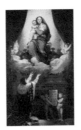

pl. 31. *The Vow of Louis XIII*, 1824, oil on canvas, 421 x 262 cm, Montauban, Notre-Dame.
The commission for the painting came from Ingres' native city in 1820. An historical event of 1636 and ritualised on 10 February 1638, Ingres laboured over the painting during his four years in Florence. When shown in the Salon of 1824, it was one of Ingres' most significant successes.

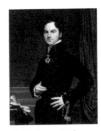

pl. 32. *Portrait of Amédée-David de Pastoret*, 1826, oil on canvas, 103 x 83.5 cm, Chicago, The Art Institute of Chicago, inv. 1971.452.
The sitter was 32 years old when Ingres painted him; Pastoret would become a devout admirer of Ingres' works, owning seven canvases. Although completed in 1826, the portrait was probably begun three years earlier. Only two studies for the portrait exist.

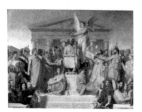

pl. 33. *The Apotheosis of Homer*, 1827, oil on canvas, 386 x 512 cm, Paris, Musée du Louvre, inv. 5417.
The huge painting with dozens of artists, writers, and philosophers, was commissioned in 1826 to decorate the Salle Clarac in the Louvre; it was replaced by a copy by Ingres' student Raymond Balze.

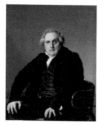

pl. 34. *Portrait of Louis-François Bertin*, 1832, oil on canvas, 116 x 95 cm, Paris, Musée du Louvre, inv. RF 1071.
The portrait is of the most powerful newspaper man of the epoch, the editor of the *Journal des Débats*. Bertin and Ingres probably met through the son of the former, a painter who studied with Ingres earlier. Ingres' hesitation over the pose is attested to in various studies which show the subject in different attitudes.

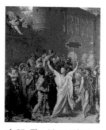

pl. 35. *The Martyrdom of Saint Symphorian*, 1834, oil on canvas, 407 x 339 cm, Autun, Saint-Lazare.
The painting took almost a decade of development in Ingres' mind, having already been announced in 1827. The subject revolves around Symphorian, the first Christian martyr of Gaul, who was sentenced to death for his refusal to worship the pagan idols in *Augustodunum* (present-day Autun). At the upper left on the rampart, the saint's mother Augusta spurs her son to die for his beliefs.

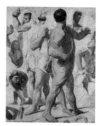

pl. 36. *Study for The Martyrdom of Saint Symphorian*, 1834, oil on canvas, 61 x 50 cm, Montauban, Musée Ingres, inv. MI 49.1.
Ingres painted several oil studies of the details so as to perfect the composition [see pl. 35], many of these as seen here as fragmented as concentrated efforts to provide accurate gestures and attitudes.

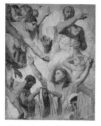

pl. 37. *Study for The Martyrdom of Saint Symphorian*, 1834, oil, graphite, and red chalk on canvas, 61.3 x 49.3 cm, Cambridge, Mass., Harvard University Art Museums, Fogg Art Museum, Grenville L. Winthrop Bequest, inv. 1943.245.
This example is one of the finest in the series of studies [see pls. 35, 36], with the rider behind the saint brilliantly studied in his foreshortened space. It is yet another example of the extraordinary care Ingres took in planning his large compositions.

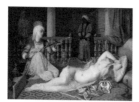

pl. 38. *Odalisque with a Slave*, 1840, oil on canvas, 72 x 100.3 cm, Cambridge, Mass., Harvard University Art Museums, Fogg Art Museum, Grenville L. Winthrop Bequest, inv. 1943.251.
The work was sold by Ingres to his friend Marcotte, whose son inherited it before it left the family in 1875. It is one of Ingres' most luxurious paintings, drawing on a highly sensual approach in depicting the nude and her surroundings.

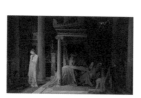

pl. 39. *Antiochus and Stratonice*, 1840, oil on canvas, 57 x 98 cm, Chantilly, Musée Condé, inv. PE 432.
Commissioned by the Duc d'Orléans in 1834, the scene from Plutarch was painted in several variations of which this one is the most developed; the decor is especially studied, recalling David's finest works. Some of the details were painted by Ingres' favourite students, Balze and Balthard.

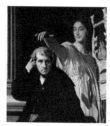

pl. 40. *Cherubini and the Muse of Lyric Poetry*, 1842, oil on canvas, 105.1 x 94 cm, Paris, Musée du Louvre, inv. 5423.
Ingres prepared three canvases of Cherubini's portrait, the first of which was begun as early as 1834, before Ingres' departure for Rome. According to a pensionnaire at the Academy in Rome who saw the work in Ingres' studio, the head of the composer was painted years before and sewn into the canvas representing the Muse Terpischore.

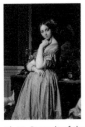

pl. 41. *Portrait of the Comtesse d'Haussonville*, 1845, oil on canvas, 131.8 x 92 cm, New York, The Frick Collection, inv. 27.1.81.
Louise, Comtesse de Haussonville, the granddaughter of Mme de Staël, married at the age of 18. She was herself a very cultivated member of society who published several biographies, including one on Lord Byron. The portrait was begun in 1842, but did not reach completion, after many false starts on Ingres' part, until three years later.

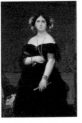

pl. 42. *Portrait of Madame Moitessier*, 1851, oil on canvas, 147 x 100 cm, Washington, D. C., National Gallery of Art, Samuel H. Kress Collection, inv. 1946.7.18.
It was Marcotte who first suggested that Ingres paint Marie-Clothide-Inès Moitessier, née de Foucauld. Ingres at first demurred, but when he met the model for the first time, he agreed to paint her portrait. It was begun in the 1840s but left unfinished when Ingres became depressed. He returned to the work at the age of 71. He would paint another portrait of the same model five years later [see plate 43].

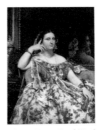

pl. 43. *Portrait of Madame Moitessier*, 1856, oil on canvas, 120 x 92.1 cm, London, The National Gallery, inv. NG 4821.
The portrait was based on a fresco from Herculaneum, *Herakles Finding his Son Telephos*, which had been excavated in 1739 and transferred to the Museo Borbonico in Naples in Ingres' day. He also owned copies and engravings of the work, from which he drew the first portrait head of the sitter in this pose, but in reverse. Ingres signed the painting under the mirror at the right: "J. Ingres 1856 / AET LXXVI"—that is, age 76.

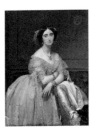

pl. 44. *Portrait of Princess de Broglie*, 1853, oil on canvas, 121.3 x 90.8 cm, New York, The Metropolitan Museum of Art, Robert Lehman Collection, 1975, inv. 1975.1.186.
This portrait of Joséphine-Elénore-Marie-Pauline de Galard de Brassac de Béarn, was Ingres' last commissioned portrait of a female sitter. She died at the age of 35, and her husband kept the portrait behind draperies in memory of his wife. The canvas remained in the Broglie family and still has the original ornate frame Ingres himself had selected.

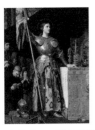

pl. 45. *Joan of Arc at the Coronation of Charles VII*, 1854, oil on canvas, 240 x 178 cm, Paris, Musée du Louvre, inv. MI 667.
A brilliant example of Ingres' late style, the image was reworked from an illustration published in *Le Plutarque français* in 1847 (vol. II, 140). The painting, however, is more focused, with the figure of Joan much larger. Ingres also added the figures at the left, which include a self-portrait as the standing figure.

pl. 46. *La Source*, 1856, oil on canvas, 163 x 80 cm, Paris, Musée d'Orsay, inv. RF 219.
Although the work was begun in Florence, Ingres did not finish it until he was in Paris when he was 76 years old. As with many of his later works, he called in assistants to help with parts of the canvas, in this case Balze and Desgoffe, who were known to have painted sections of the background.

pl. 47. *The Turkish Bath*, 1862, oil on canvas, 108 x 110 cm, Paris, Musée du Louvre, inv. RF 1934.
Painted as an oval on a square frame, this was the last canvas Ingres executed; he was 82 years old. The work once belonged to the Turkish ambassador to France, Khalil Bey, whose collection of erotic art was well known. The canvas was included in the Salon d'Automne of 1905, where Picasso was impressed by its sensual beauty. It did not enter the Louvre until 1911.

pl. 48. *Self-Portrait*, 1858, oil on canvas, 62 x 51 cm, Florence, Gallerie degli Uffizi, inv. 1948.
In 1839, while Ingres was director of the Academy in Rome, the director of the Uffizi, Antonio Ramirez di Montalvo, asked him to provide a self-portrait, which he had to decline. But Ingres accepted the invitation when it was renewed in 1855 by the new director, Marchese Bourbon del Monte. Ingres, who had used a photograph for the likeness, sent the work to Florence in March 1858. A second version, painted in 1864–65, is in Antwerp.

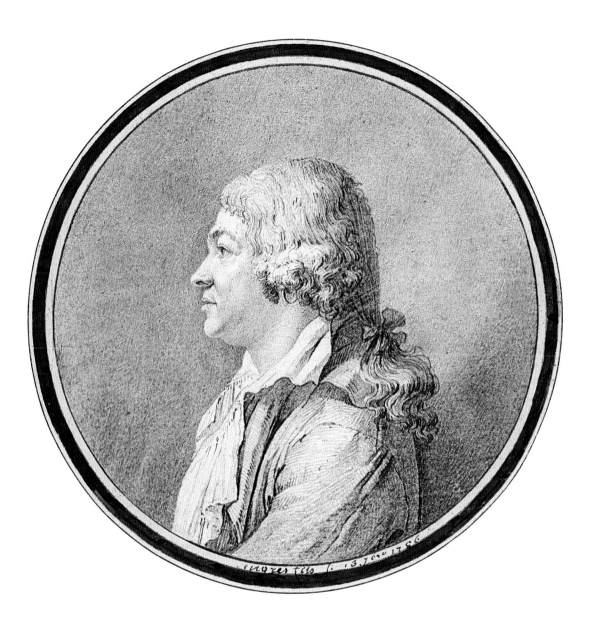

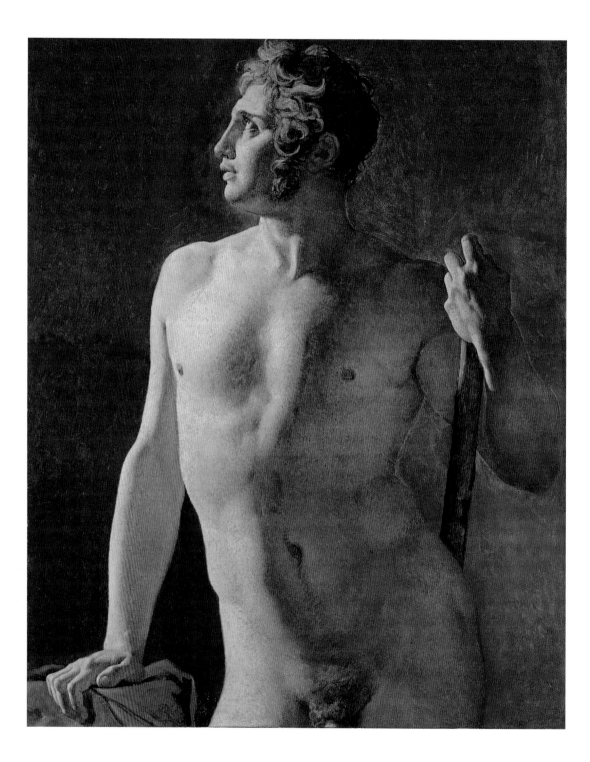

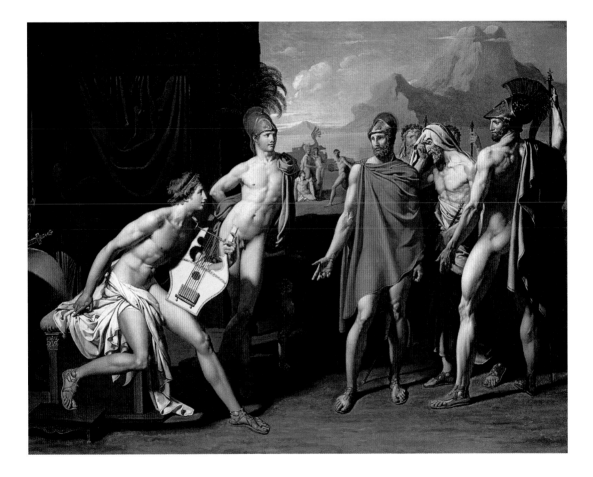

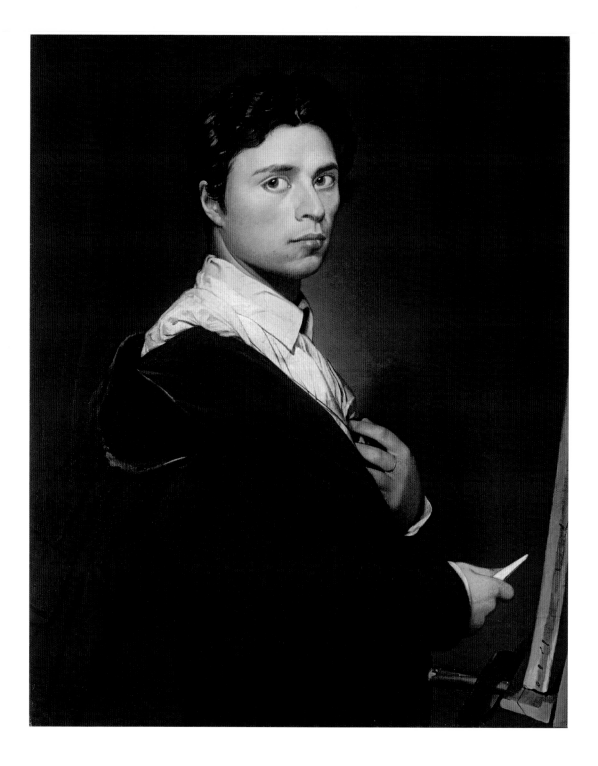

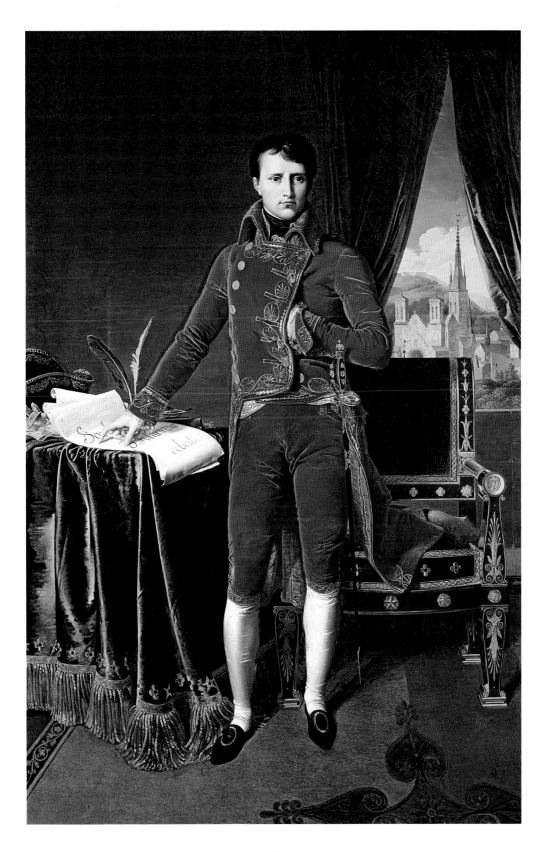

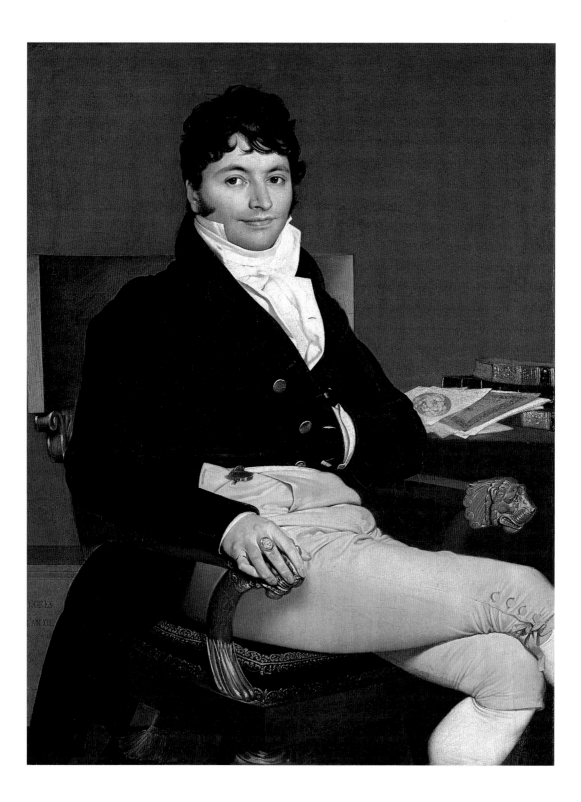

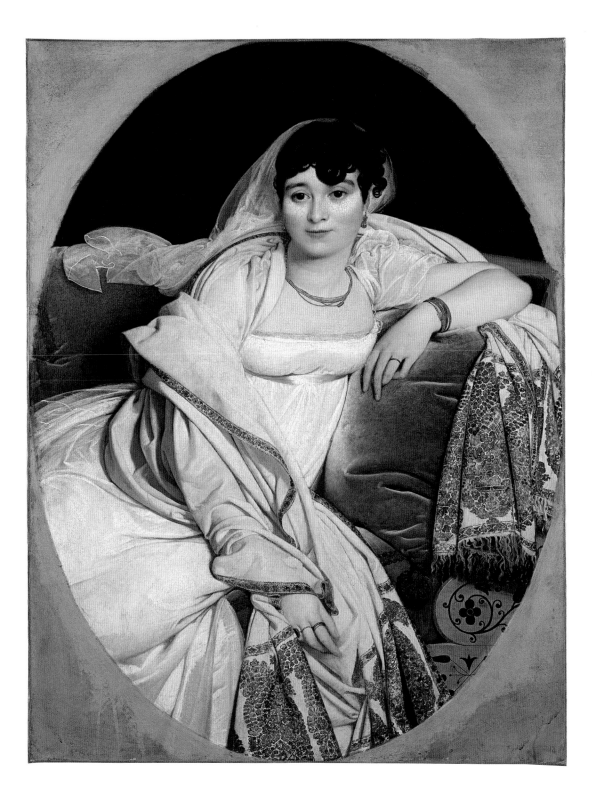

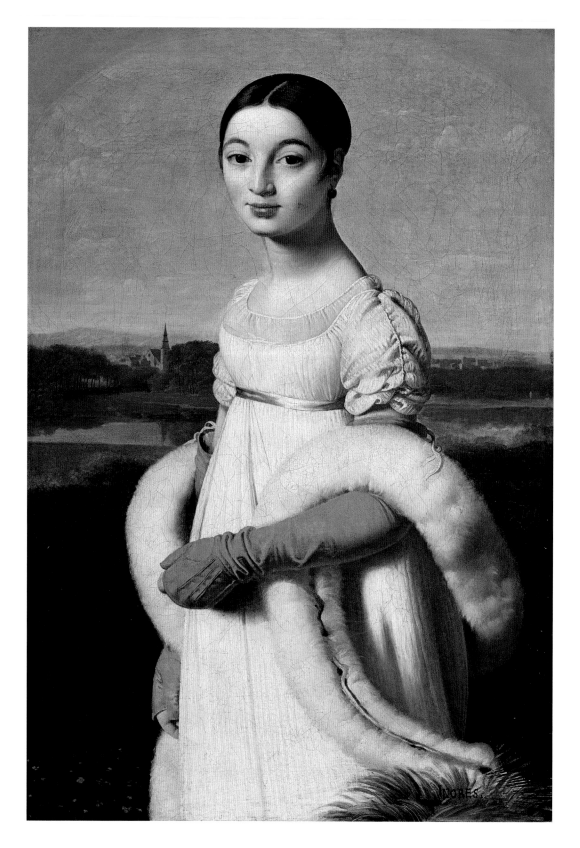

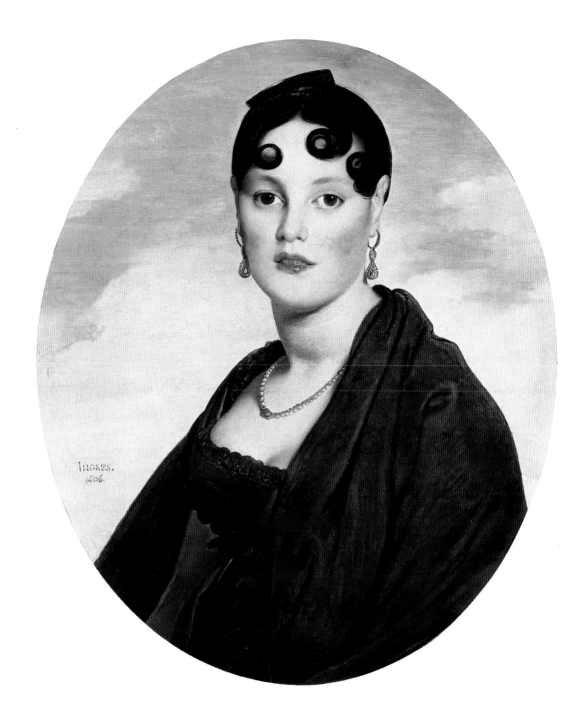

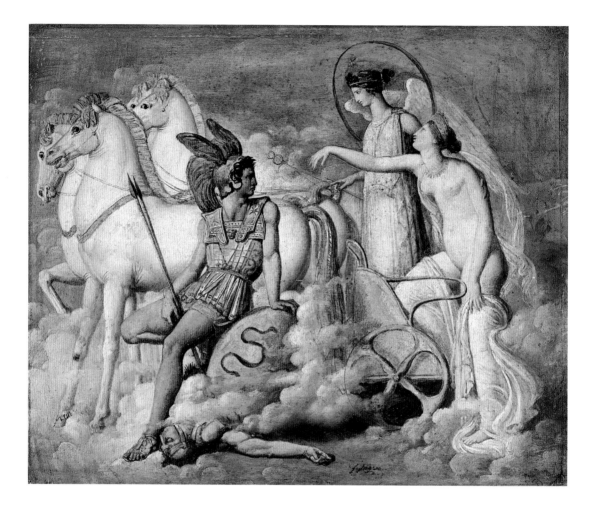

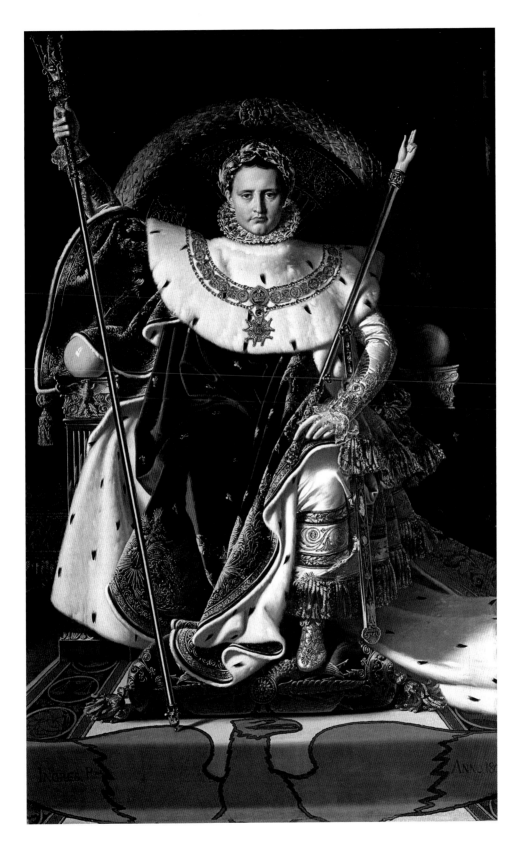

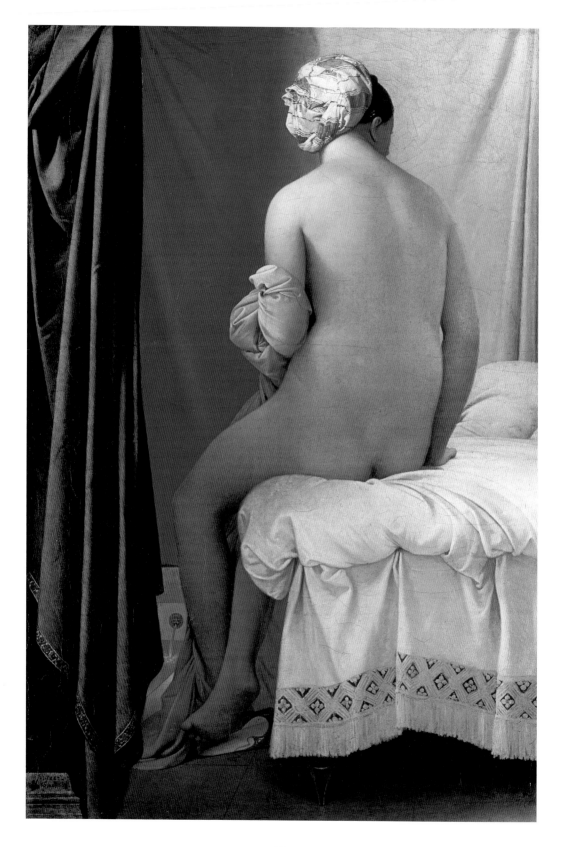

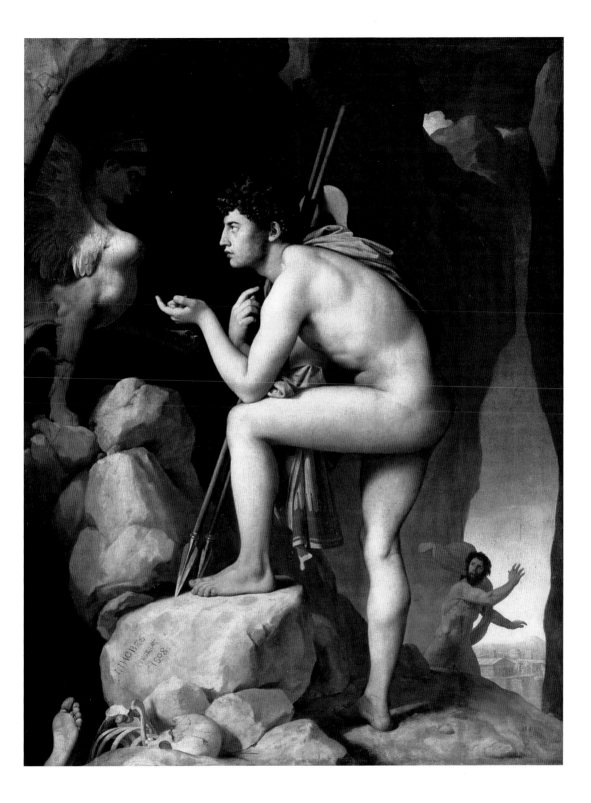

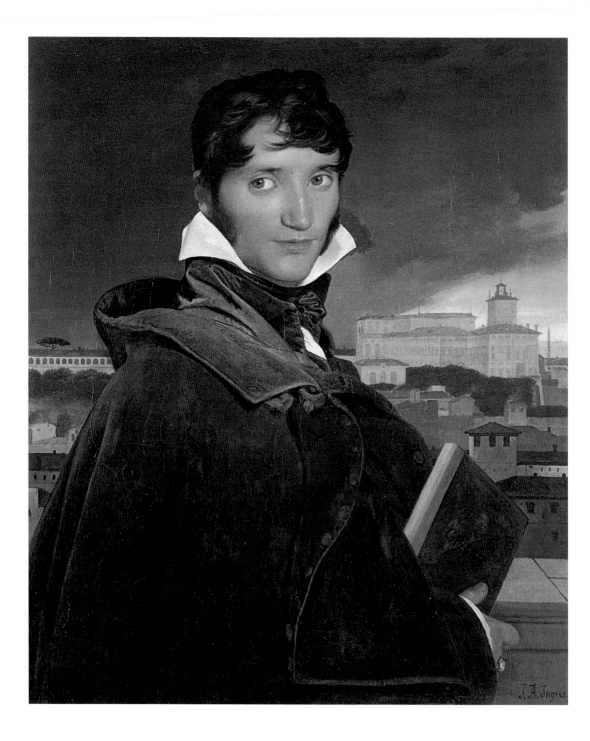

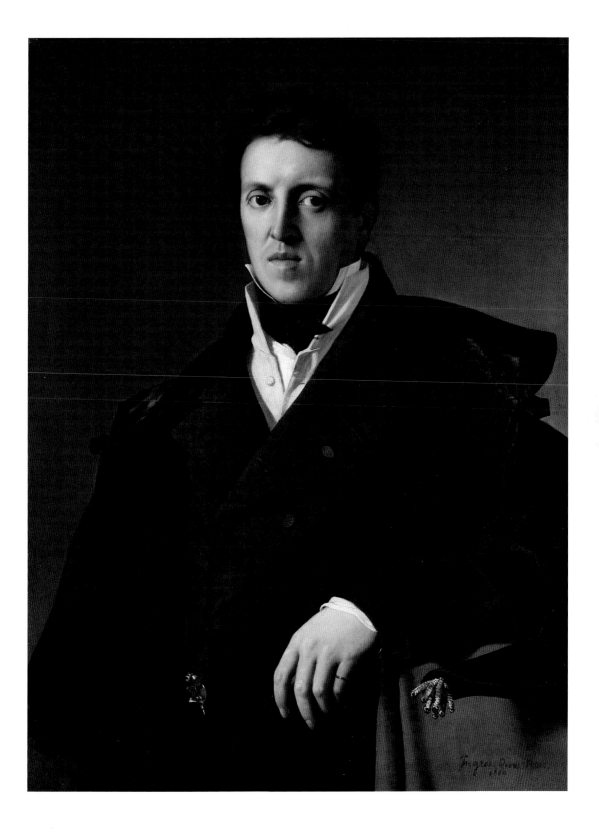

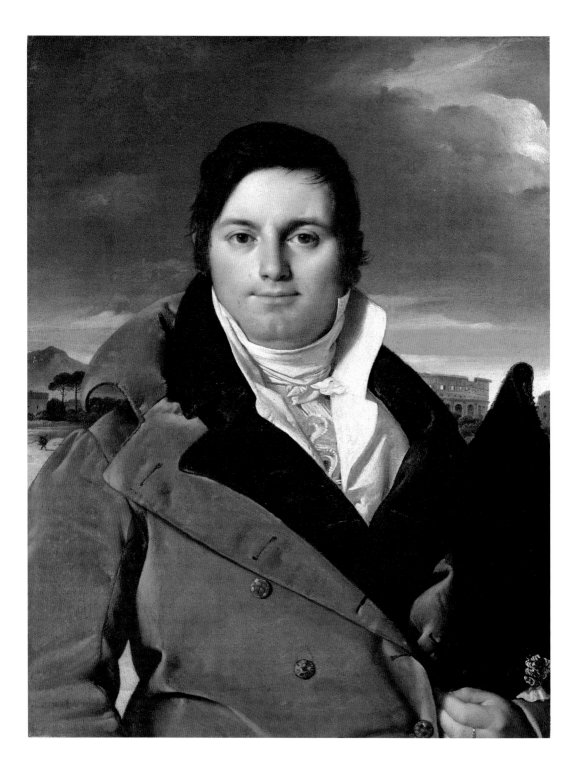

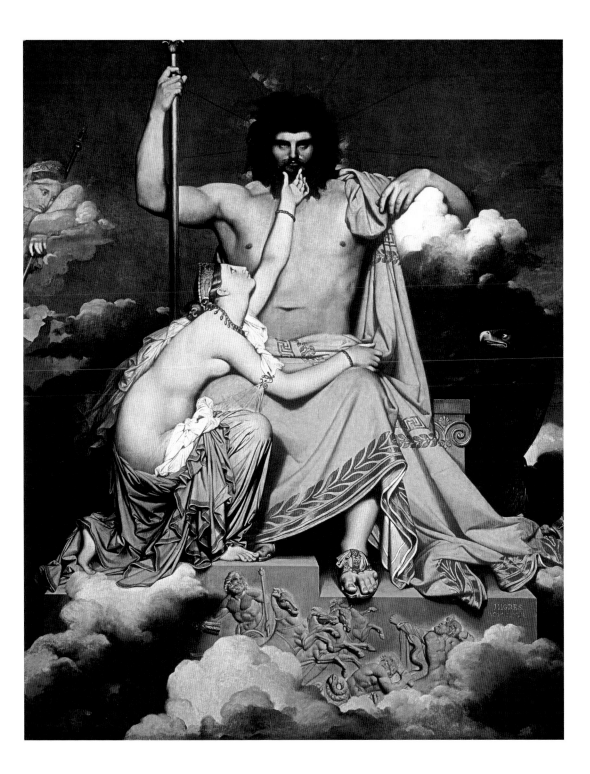

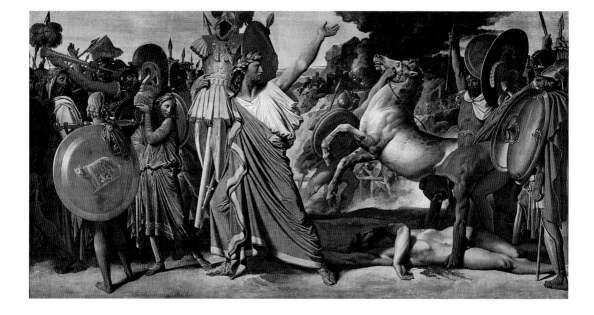

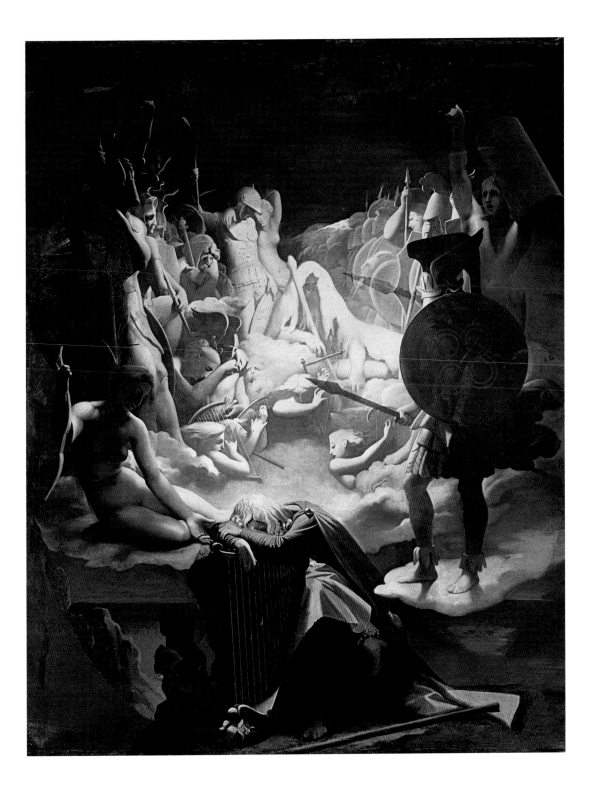

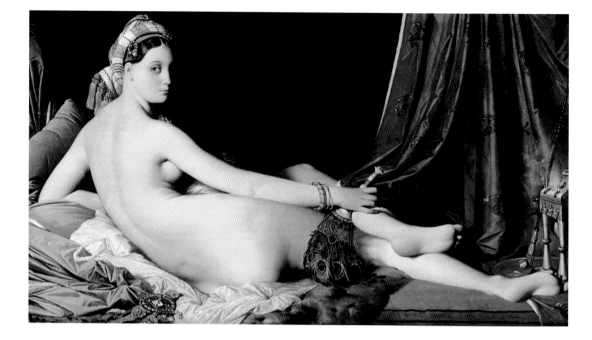

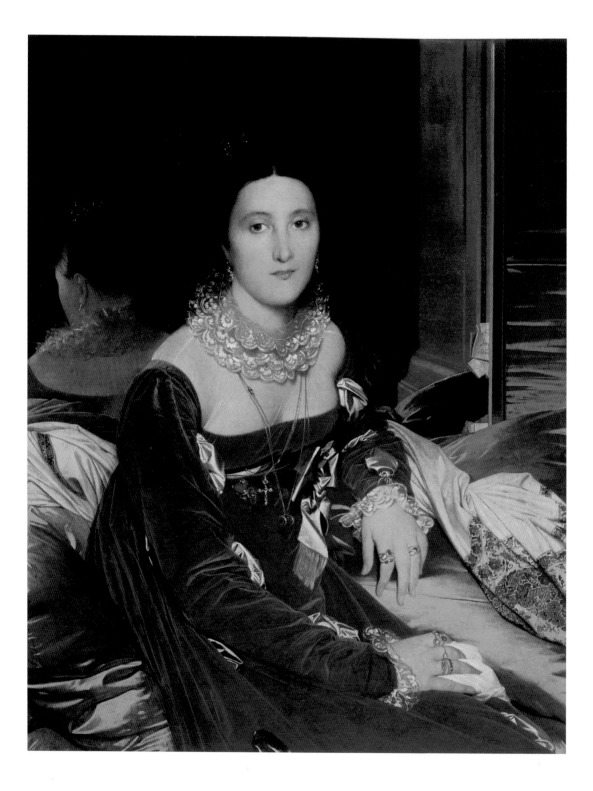

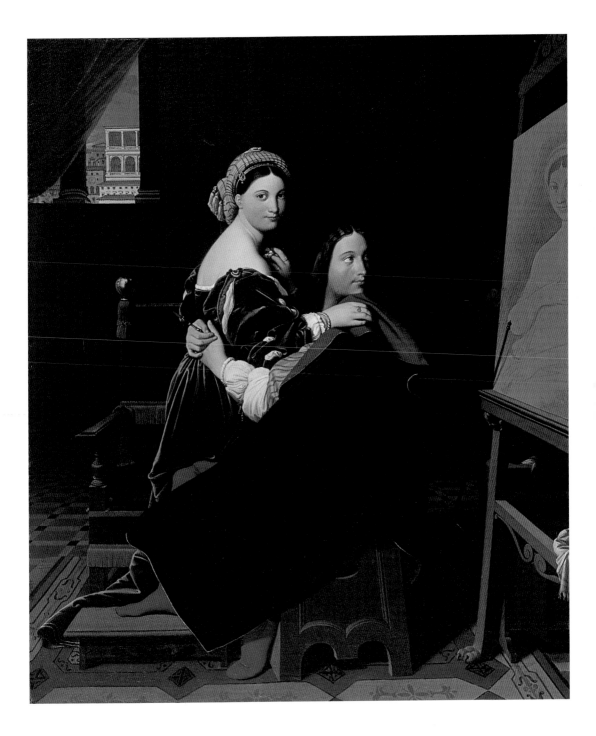

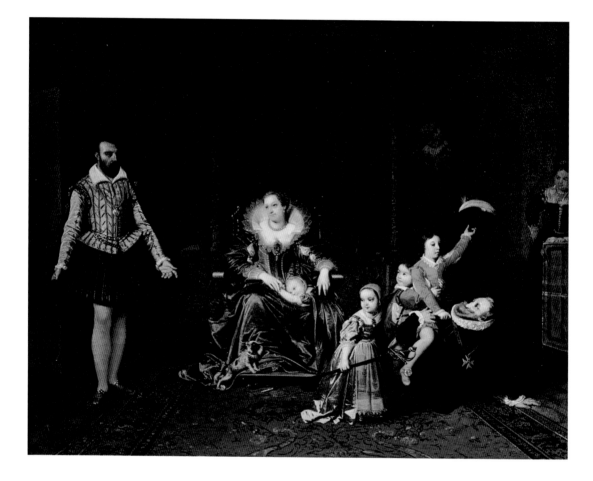

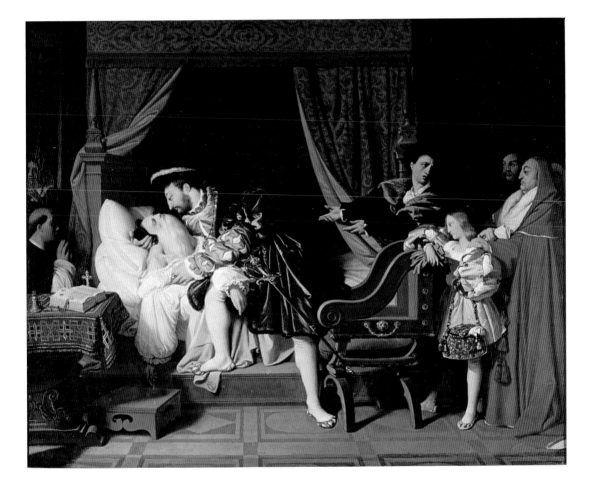

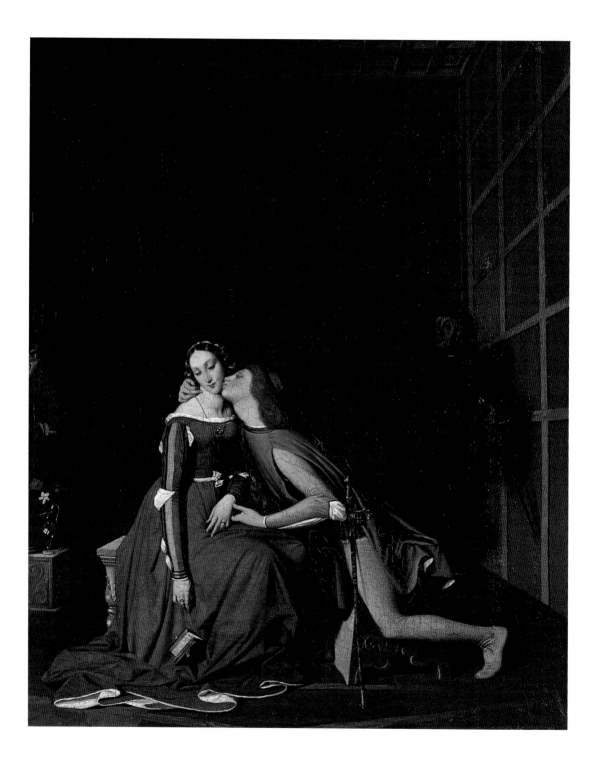

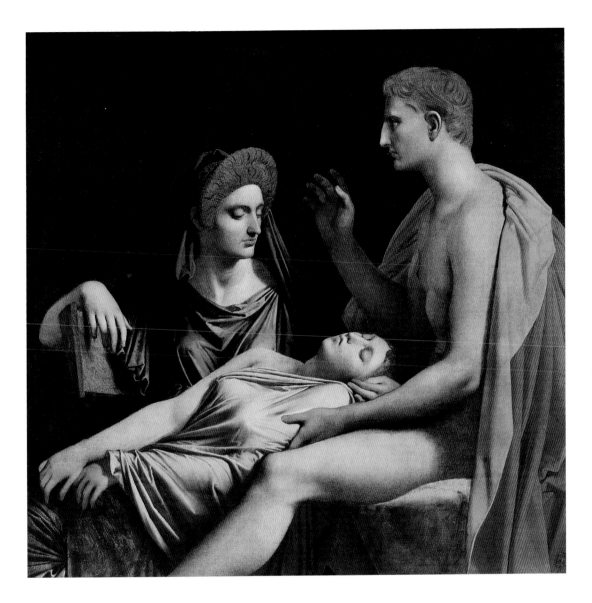

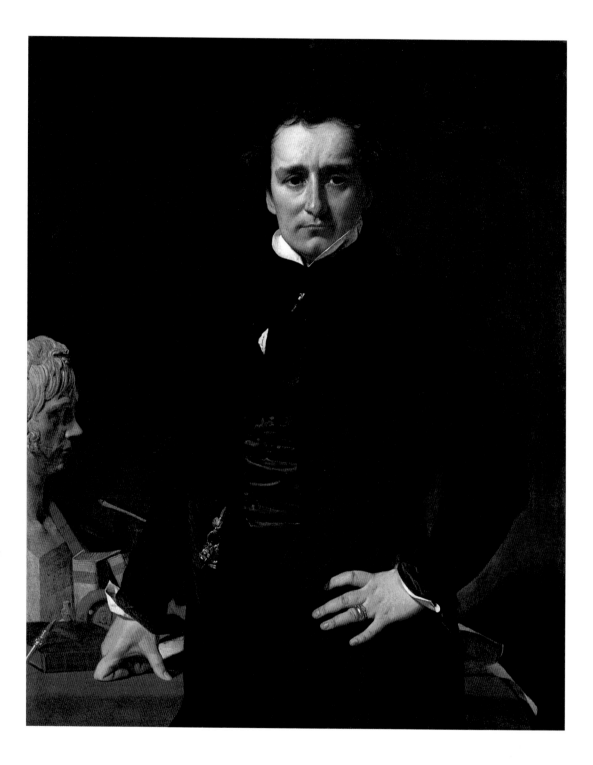

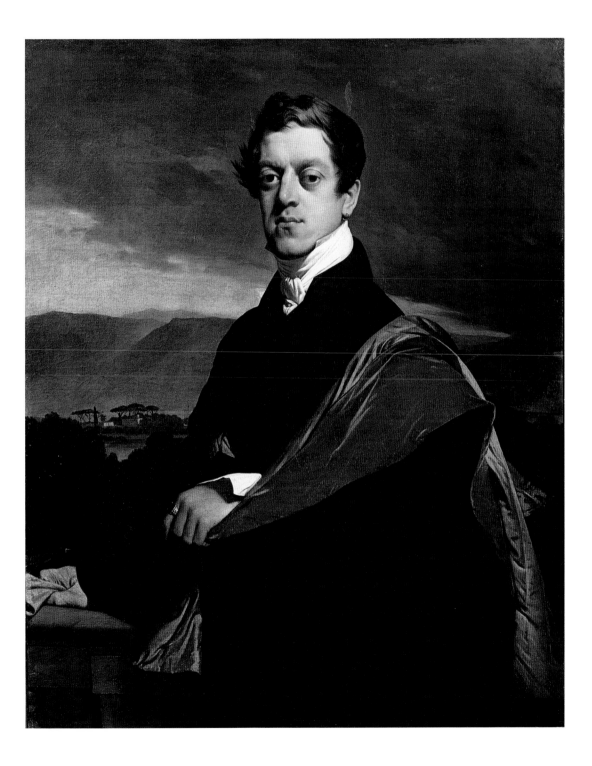

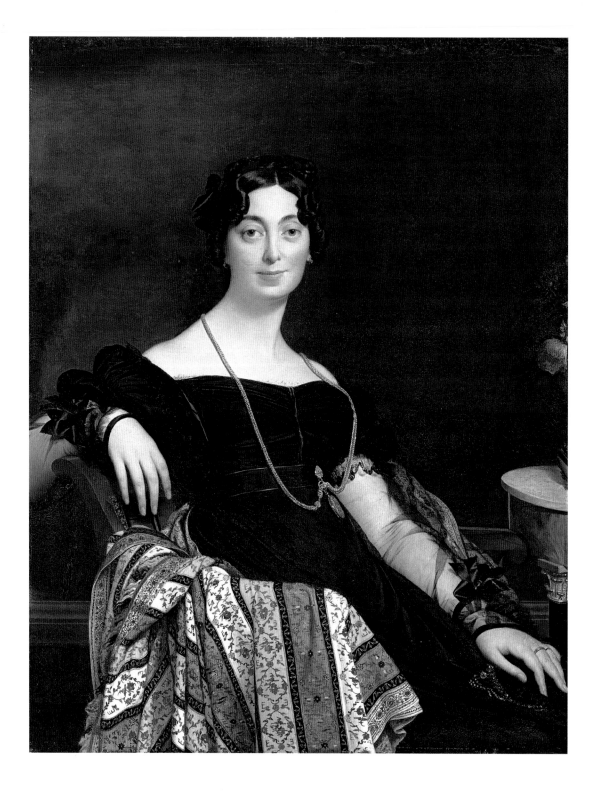

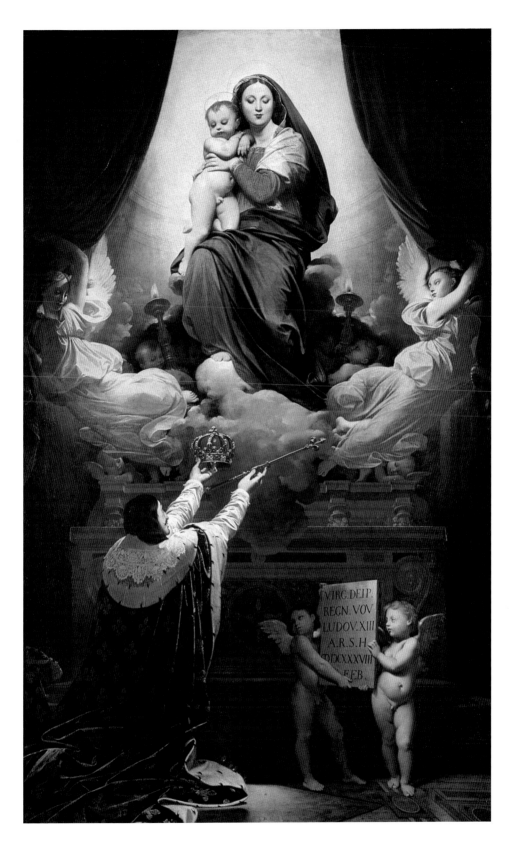

The text visible within the image reads:

VIRG. DEIP.
REGN. VOV
LUDOV. XIII
A. R. S. H
MDCXXXVIII
FEB.

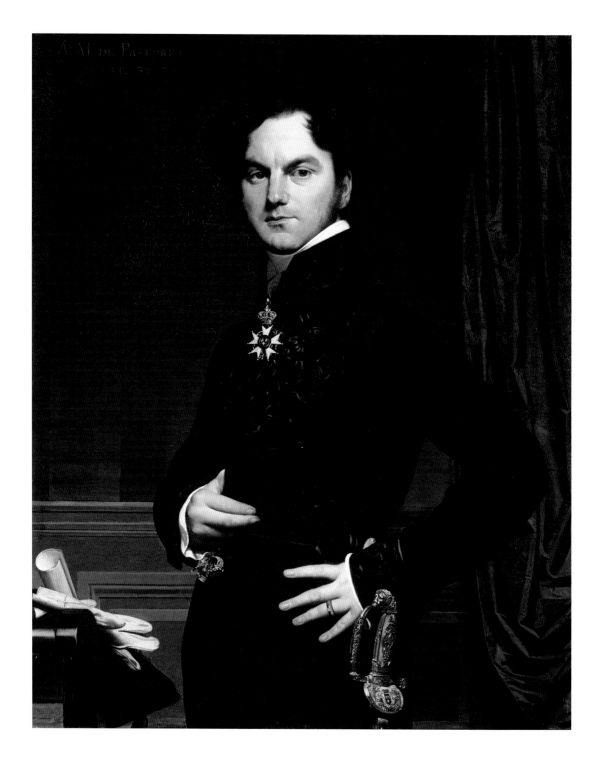

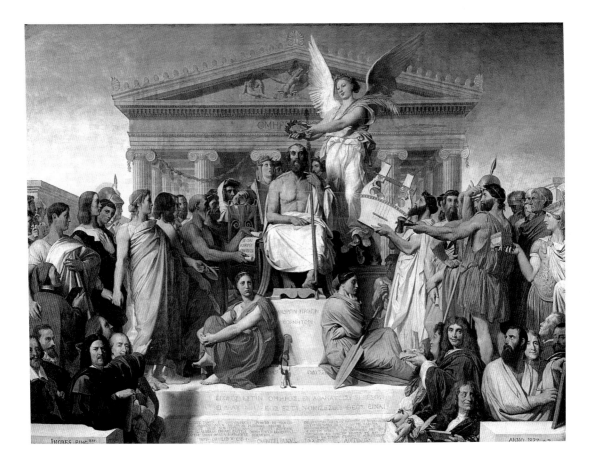

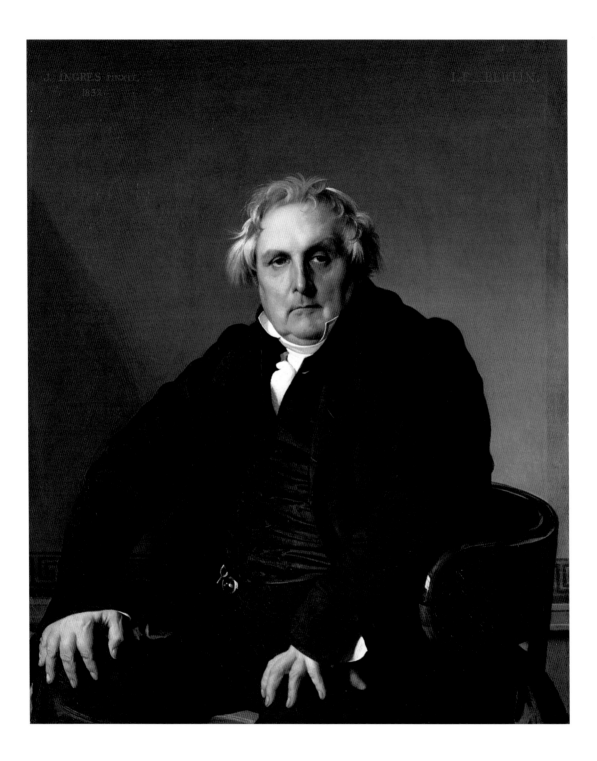

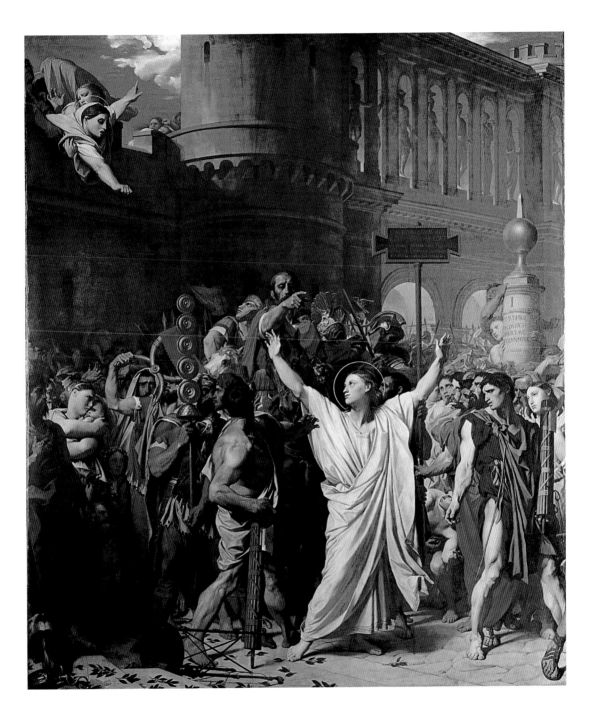

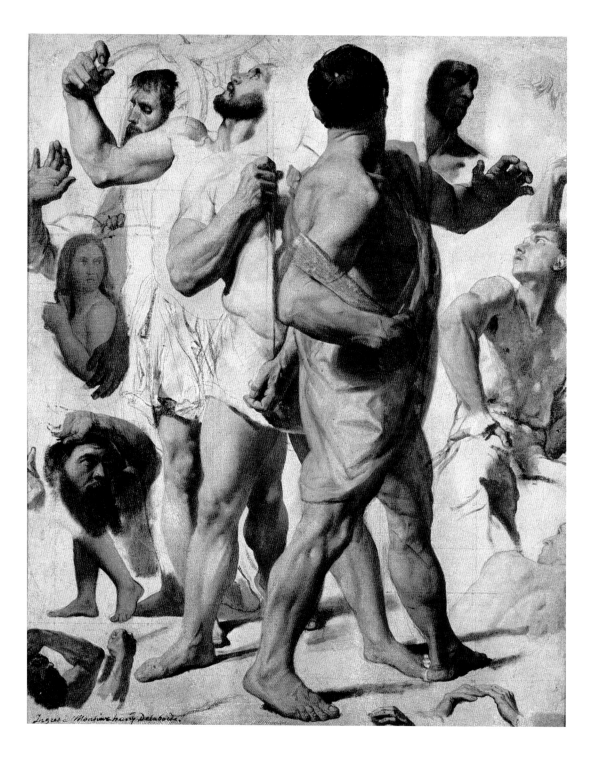

Ingres à Monsieur henry delaborde.

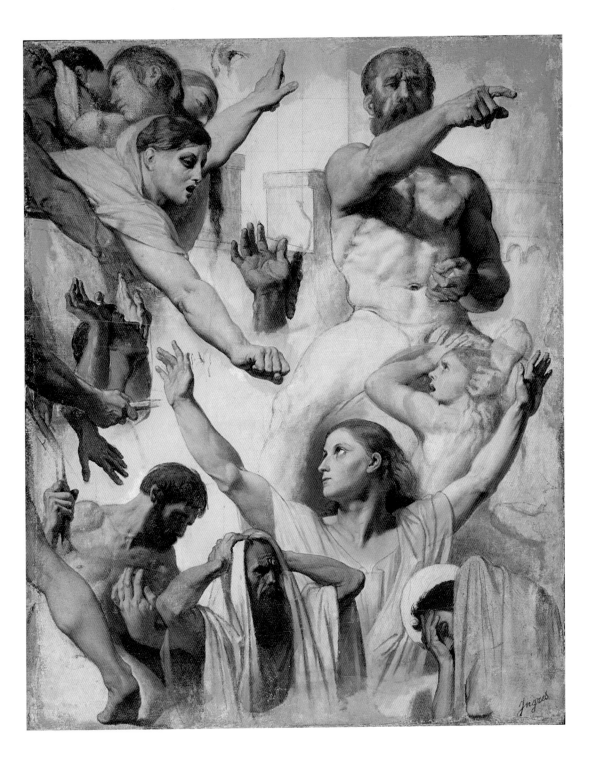

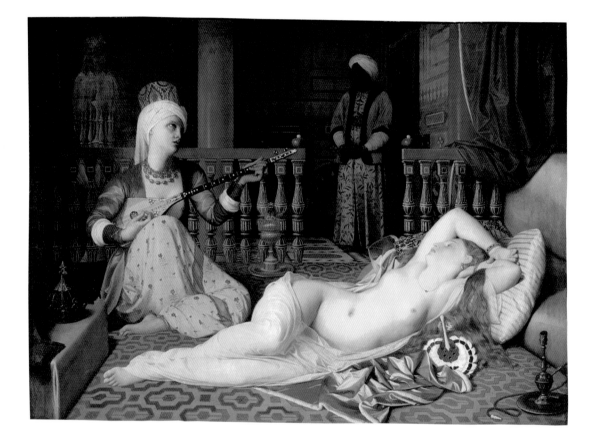

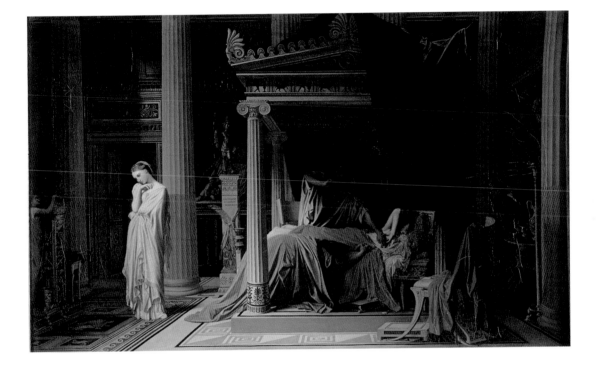

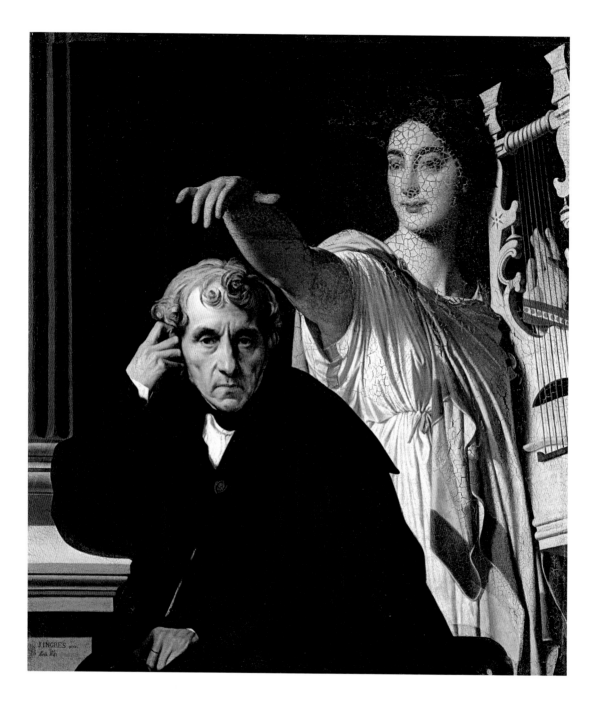

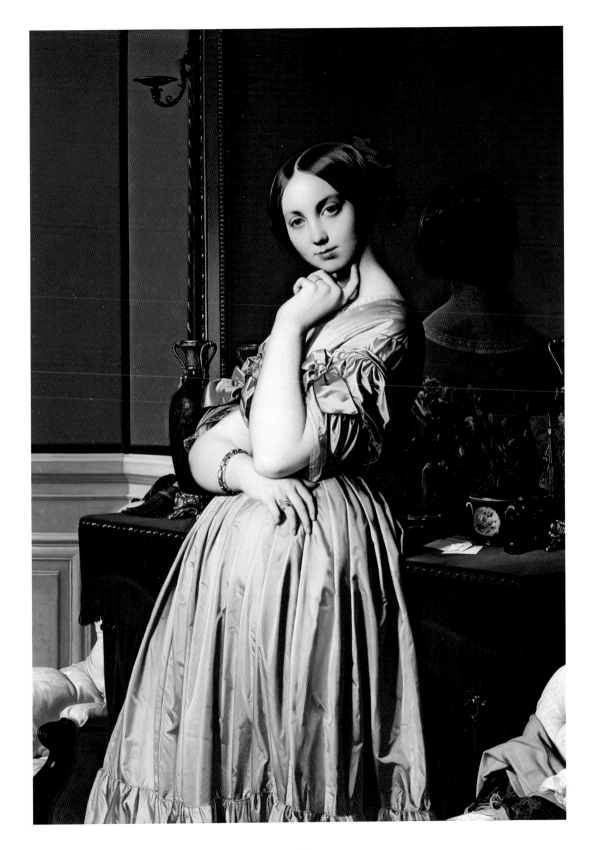

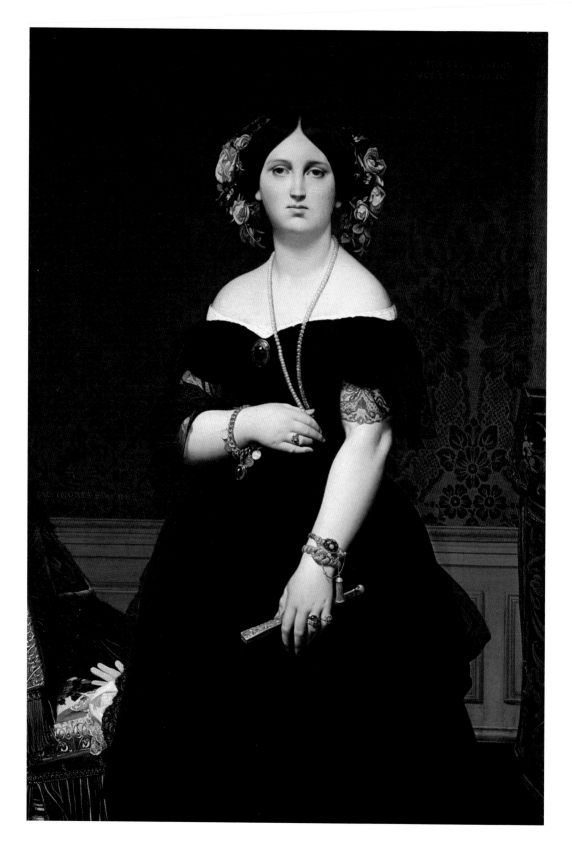

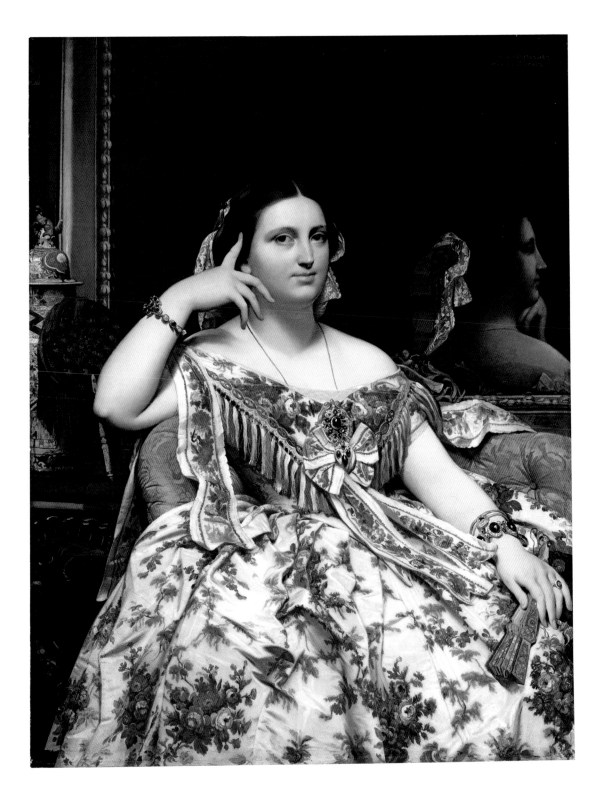

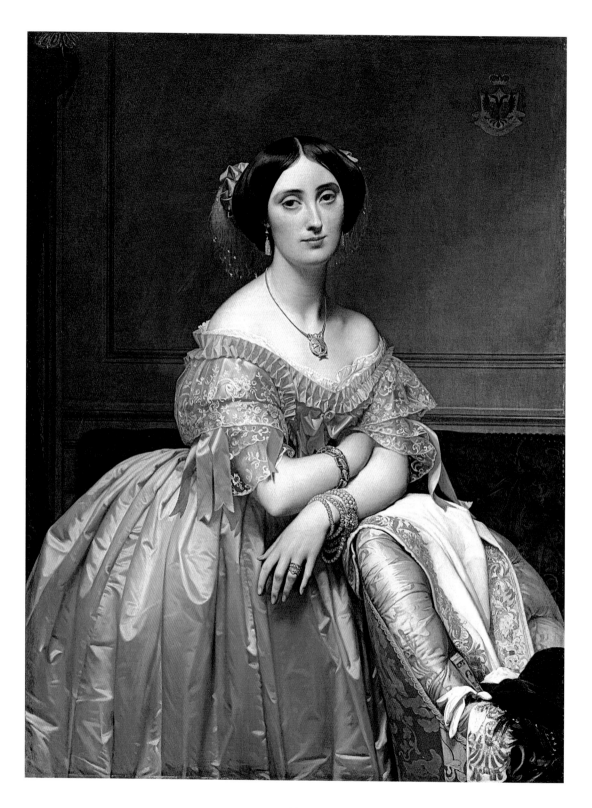

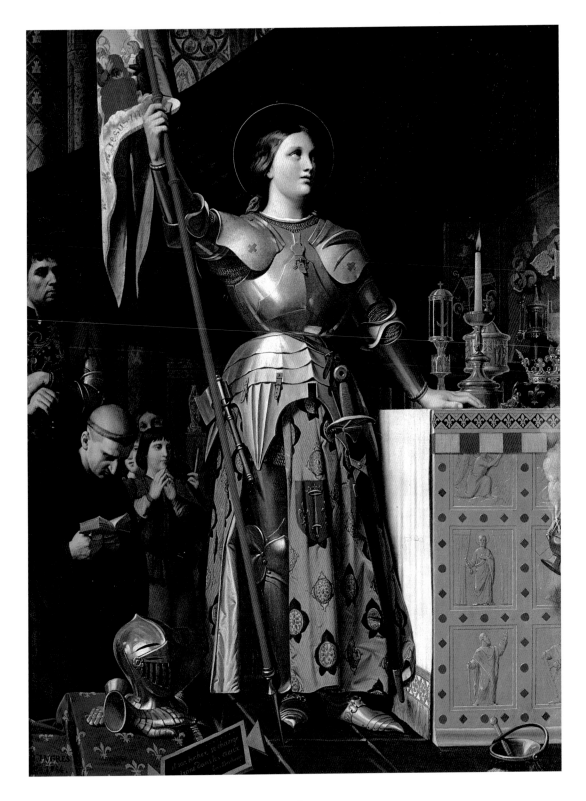

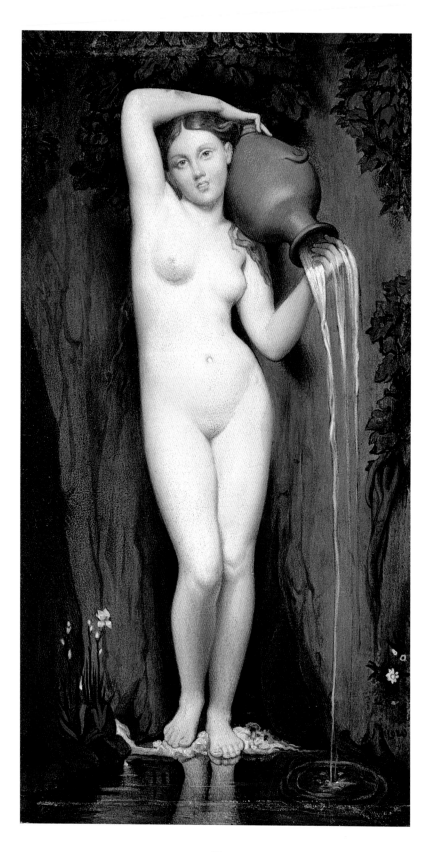

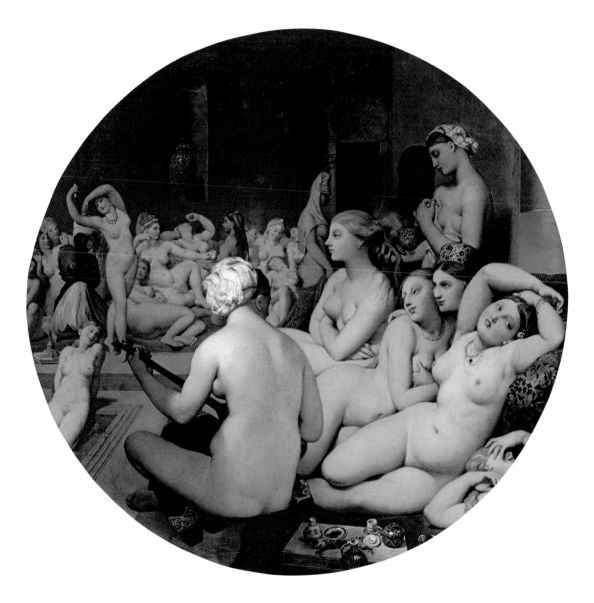

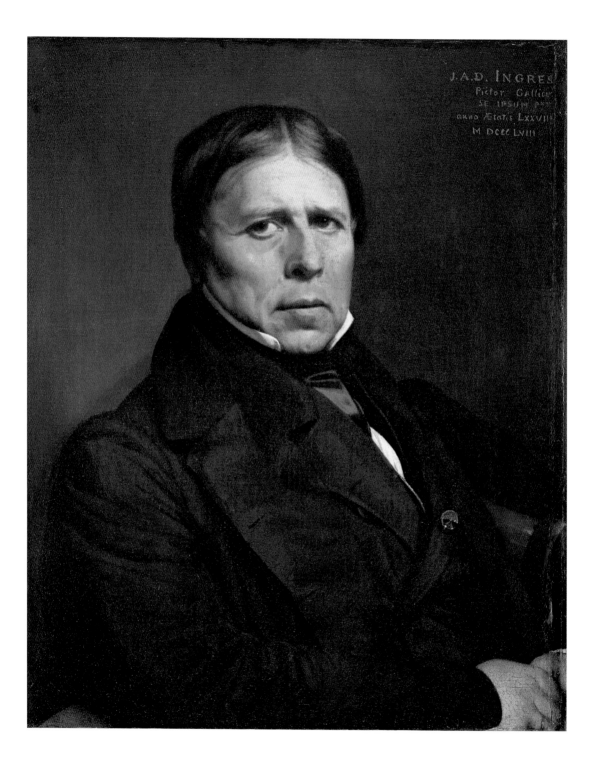

APPENDICES

1780
29 August: Jean-Auguste-Dominique Ingres,
born in Montauban, son of Jean-Marc-Joseph
Ingres, a painter and decorative sculptor, and
Anne Moulet, the daughter of a wig-maker;
the oldest of five children.

1789
One of Ingres' first drawings, after the cast
of an antique bust.

1791
Enters the Toulouse Academy, studying with
Guillaume-Joseph Roques, Jean-Pierre Vigan,
and Jean Briant.

1792
19 August: wins the third award for the figure
and antique class.

1793
31 May: receives first prize in model class
(*Figure en ronde bosse*).

1794
Studies violin with the musician Lejeune,
becomes second violinist in the local orchestra.

1796
Wins second prize in the life class and first
prize in the composition contest.

1797
August: with Roques *fils*, goes to Paris
and enters David's studio.

1799
24 October: enters the École des Beaux-Arts
as a painting student, forty-fourth of
eighty-eight candidates.

1800
2 February: wins first prize in the torso
category (*Demi figure*). Works with

David on his portrait of Madame Récamier.
4 October: wins second place in the Prix
de Rome competition (first prize was given to
Jean-Pierre Granger, another pupil of David).

1801
20 March: enters Prix de Rome contest
for the second time.
29 September: wins first prize in the Prix
de Rome competition, but due to financial
difficulties of the French state he can not
go to Rome immediately.

1802
The government offers Ingres a grant of
60 francs and the use of a studio in the former
convent of the Capuchins; his neighbours
include Gros, Girodet, Granet, and Bartolini.
2 September: exhibits for the first time in
the Salon.

1803
Summer: receives a commission to paint
Bonaparte as First Consul [pl. 5], which will
be unveiled in Liège two years later.

1804
Ingres *père* comes to Paris to visit his son,
who paints his portrait.

1805
Paints dozens of portraits and commences
Napoleon I on the Imperial Throne [pl. 11].

1806
June: becomes engaged to Anne-Marie-Julie Forestier.
15 September: his *Napoleon I on the Imperial
Throne* is exhibited to largely negative reviews.
September: finally receives state funds for
travel to Rome; arrives at the Villa Medici
on 11 October.

1807
Stung by the Salon criticism, Ingres breaks
his engagement so as not to return to Paris
until he is successful.

1808
Sends works to Paris in accord with the
regulations of the Prix de Rome, including
Oedipus and the Sphinx [pl. 13], and the *Bather
of Valpinçon* [pl. 12], all of which are severely
criticised.

1809
Copies works by Raphael in the Vatican
and the Villa Borghese; sells a nude to Murat,
the King of Naples (destroyed).

1810
Completes his stay at the Villa Medici
and rents a studio in Via Gregoriana.

1811
Dispatches his *Jupiter and Thetis* [pl. 17] to Paris,
the last work he sends to Paris from Rome.

1812
Ingres rents a large studio in the convent of
Trinità dei Monti to complete his vast *Romulus
Conqueror of Acron* [pl. 18] for the Quirinal
Palace. Becomes engaged to Laure Zoëga,
the daughter of a Danish archaeologist, but the
engagement is broken off soon afterwards.

1813
Asks the hand of Madeleine Chapelle,
the cousin of a mutual friend, whom he has
never met; she arrives in Rome in September;
they marry in December. Paints *The Betrothal
of Raphael* in 20 days.

1814
February: goes to Naples to paint the portrait
of Queen Caroline Murat and the royal
family (lost); she commissions the *Grande
Odalisque* [pl. 20].
14 March: Ingres *père* dies in Montauban.
November: exhibits several portraits in the
Salon which are badly received by the critics.

1815
With the downfall of the Bonapartes and the
end of French rule in Naples, he finds himself

without commissions and draws numerous
portraits of tourists and friends to survive.

1817
March: death of his mother; receives commission
from the Duc de Blacas to paint *Christ Giving
the Keys to Peter* for the church of Trinità
dei Monti. Meets Géricault.

1819
June: travels to Florence to visit Bartolini
and remains for a year.
25 August: exhibits several paintings in the Salon,
including the *Grande Odalisque*, but again his
works are ill received.

1820
Moves to Florence and receives a commission
from the cathedral in Montauban for *The Vow
of Louis XIII*; *Christ Giving the Keys to Peter*
is completed.

1823
Is elected a corresponding member
of the French Académie des Beaux-Arts.

1824
August: several works in the Salon are
again criticised, but *The Vow of Louis XIII* [pl. 31]
is acclaimed against the Romantic painters
in the same exhibition.
October: leaves Florence for Paris and receives
the commission to paint *The Martyrdom of
Saint Symphorian* [pl. 35–37] for the cathedral
of Autun.

1825
Receives the Cross of the Légion d'Honneur
from Charles X.
25 June: Ingres elected a member of the
Académie des Beaux-Arts to replace
Vivant Denon.
November: opens a studio for students in Rue
des Marais Sant-Germain (now Rue Visconti).

1826
October: commissioned for *The Apotheosis*

of Homer [pl. 33], a ceiling decoration for the Musée Charles X.
12 November: arrives in Montauban to present *The Vow of Louis XIII*, which is enthusiastically received; travels to Autun to prepare the *Martyrdom of Saint Symphorian*.

1827
4 November: *The Apotheosis of Homer* is shown still in grisaille; finished only for the Salon of 1833.

1829
30 December: Ingres is elected professor of painting at the École des Beaux-Arts, replacing Regnault.

1830
31 July: takes part in the July Revolution; along with Delacroix and others, guards paintings in the Louvre against vandalism.

1832
December: is named Vice-President of the École des Beaux-Arts for the following year.

1833
March: Sends several paintings to the Salon, including the portrait of *M Bertin* [pl. 34], but these are harshly criticised.
December: appointed President of the École des Beaux-Arts for the following year.

1834
Exhibits the *Martyrdom of Saint Symphorian*, which is not well received; vows never to exhibit in the Salon again. Embittered, he requests to succeed Horace Vernet at the Villa Medici in Rome.
5 July: is made Director of the Académie de France in Rome.
December: leaves Paris for Rome.

1835
4 January: arrives in Rome.
May/June: visits Orvieto and Siena; on his return begins to restore and enlarge the Villa Medici; adds a library; increases life-study classes;

adds courses in archaeology; and increases the collection of antique casts. Paints only sporadically.

1839
Receives an important commission from the Duc de Luynes for decorations at the Château de Dampierre near Paris.

1840
Finishes *Antiochus and Stratonice* [pl. 39], on which he has worked for years; the Duc d'Orléans doubled his salary and authorised its hanging in the Salon, to huge critical response.

1841
6 April: leaves Rome for a triumphal return to Paris. Receives acclaim; is honoured by banquets and a concert (organised by Berlioz); and receives royal and aristocratic commissions.

1842
May: finishes the portrait of the Duc d'Orléans.
25 June: petitions to have David's remains returned to Paris from Brussels.

1843
August: settles in Dampierre to work on two large allegorical paintings—4.8 x 6.6 m each— for which he will receive 70,000 francs; only one of the paintings will be worked on; the other remained in a sketch form.

1844
13 May: is honoured in Montauban; a street is named after him.

1845
Named Commander of the Légion d'Honneur.

1846
Sends 11 paintings for exhibition at the Galerie des Beaux-Arts in Boulevard Bonne-Nouvelle to aid artists' pension funds, the first time he exhibits in Paris since 1834.

1848
19 October: made a permanent member of the
Commission of Fine Arts; demands abolishment
of the jury and freedom of admission for artists.

1849
27 July: Ingres' wife dies at the age of 66;
a long period of depression; settles in an
apartment at 27 Rue Jacob; abandons the
Dampierre commission.

1850–51
Sends more than 50 canvases to Montauban,
the germ of the Musée Ingres; Albert Magimel,
a pupil, asked him to prepare his collected
works in outline form for publication.

1851
18 July: presents his collection of 50 paintings
to Montauban, to be augmented later
by drawings, books, manuscripts, etc.
25 October: resigns as professor from the École
des Beaux-Arts.

1852
15 April: aged 71, marries Delphine Ramel,
43 years old.

1853
2 March: is commissioned for a ceiling
decoration, *The Apotheosis of Napoleon I*, for the
Hôtel de Ville, much admired by Napoleon III
(destroyed in 1870).

1854
15 May: inauguration of the Salle Ingres
in the Hôtel de Ville, Montauban.

1855
15 May: at the Exposition Universelle, shows
a selection of 43 paintings; first retrospective
of his works; meets Degas.

1858
20 March: delivers a self-portrait to the Uffizi
[pl. 48].

1861
Friends organise an exhibition at the Salon
des Arts Unis of 92 drawings, the first time
the public saw this aspect of his art.

1862
25 May: made Sénateur.
1 June: 250 French artists present him with a medal.

1865
After being made a member of the Royal Fine
Arts Academy in Antwerp, he sends the museum
a self-portrait at the age of 85.

1867
8 January: makes a tracing of a fresco by Giotto,
the last work from his hand; on the same
day catches cold and then pneumonia.
14 January: dies at 1 o'clock in the morning
at 11 Quai Voltaire.
Posthumous exhibition held at the École
des Beaux-Arts comprising 584 of the artist's
paintings.

1869
The Musée Ingres at Montauban is inaugurated.

ANNOTATED BIBLIOGRAPHY

It is not unexpected that the bibliography on Ingres is expansive. Almost every form of study—from the purely formalistic to the feminist perspective—is represented in the Ingres literature, which in the last half century has more than doubled the writings of earlier decades. Monographs, biographies, letters, student reminiscences, specialised articles, colloquia, and dozens of other forms are found in great abundance. The following list is intended to provide some of the most important examples for the student of Ingres. By definition it can not be complete; it can only provide an idea of how very well studied Ingres' paintings, drawings, and career has been. There is as yet no wholly scientific catalogue raisonné of Ingres' painting in the half century the publication of after Georges Wildenstein's *Jean-Auguste-Dominique Ingres* (London: Phaidon Press, 1954), which was revised two years later and contained 325 catalogue numbers. The bulk of Ingres' work in oils has been collected by Daniel Ternois and Ettore Camesasca, *Tout l'œuvre peint d'Ingres* (Paris: Flammarion, 1971) with a new edition published in 1984. His drawings, however, have been particularly well served, especially Hans Naef, *Die Bildniszeichnungen von J.-A.-D. Ingres* (Bern: Bentelli, 1977–80), published in five volumes, a work of authority on the whole range of Ingres' production on paper. His immense collection of drawings at Montauban, willed to the museum by Ingres himself, has been studied first by Daniel Ternois, *Les dessins d'Ingres au musée de Montauban: Les portraits* (Paris: 1959), and then by Georges Vigne, *Dessins d'Ingres: catalogue raisonné des dessins du musée de Montauban* (Paris: Gallimard and Réunion des musées nationaux, 1995), who listed more than 4,500 catalogue numbers.

Dozens of major exhibitions have been devoted to Ingres' work, starting with the first major retrospective mounted only months after his death in 1867 as a memorial exhibition at the École des Beaux-Arts: *Catalogue des tableaux, études peintes, dessins et croquis de J.-A.-D. Ingres, peintre d'histoire, sénateur, membre de l'Institut*. It remains the largest exhibition of Ingres' work ever mounted: 150 paintings and 430 drawings, but the catalogue in question however was only a checklist of 68 pages. In the course of the twentieth century, there have been dozens of loan exhibitions from the rich holdings of the Musée Ingres in Montauban, which have been seen in different forms in almost all of the principal museums in America and Europe, as well as the Middle East and Japan. As to retrospectives, the first major one in our times is *Ingres*, held at the Petit Palais in Paris, 1967–68, honouring the centennial of Ingres' death, did much to revive interest in Ingres' work. A complementary exhibition of Ingres' drawings was *Ingres Centennial Exhibition, 1867–1967: Drawings, Watercolors, and Oil Sketches From American Collections* (Cambridge, Mass.: Fogg Art Museum, 1967), with an expert essay by Agnes Mongan. But in the United States, the only substantial large-scale retrospective was *In Pursuit of Perfection: The Art of J.-A.-D. Ingres* (Louisville: Speed Museum, 1983–84).

Nonetheless, there have been numerous thematic exhibitions such as *Ingres in Italia, 1806–1824, 1835–1841* (Rome: Académie de France, 1968), which underscored the importance of Ingres' Roman sojourns. Additional thematic exhibitions of note was *Ingres and the Comtesse d'Haussonville* (New York: Frick Collection 1985–86), an exemplary show that explored a single painting in an encyclopaedic manner. For the portraits in general and the crucial role they played in Ingres' art, the exhibition of reference is *Portraits By Ingres. Image of an Epoch*, curated by Gary Tinterow and Philip Conisbee, first seen in The National Gallery, London, 1999 and then in Washington and New York. The massive catalogue documents every stage of Ingres' career, with a substantial

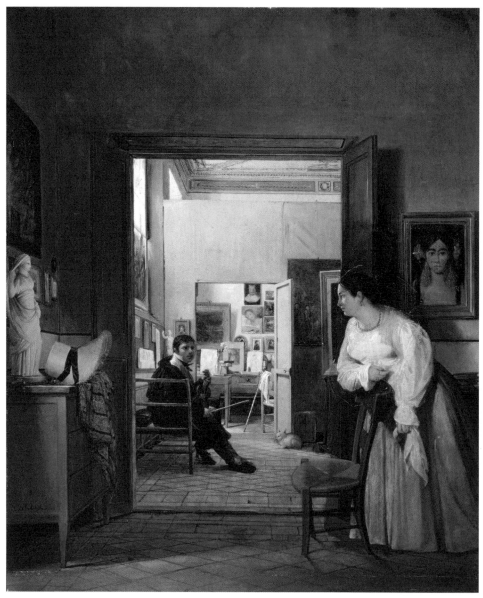

Fig. 6. Jean Alaux, *The Ingres Studio in Rome*, 1818, oil on canvas, 55.5 x 46 cm, Montauban, Musée Ingres.

chapter by Andrew Carrington Shelton on the critical reception; the bibliography is certainly one of the most complete in the literature. An exemplary exhibition catalogue to consult as well is Georges Vigne and Marie-Hélène Lavallée, *Les élèves d'Ingres* (Montauban: Musée Ingres, 2000), which explores and documents all of Ingres' pupils and the role of his teaching methods.

Before biographies began to appear after Ingres' death, Albert Magimel published *Œuvres de J. A. Ingres, membre de l'Institut, gravées au trait d'acier par A. Revoil* (Paris: no publisher, 1851). This edition, with 102 plates of Ingres' work from 1800 until 1850, was the first publication to include a large number of works, albeit reduced to linear engravings. When Ingres died in 1867, proper biographies began to be published with Charles Blanc, "Ingres: sa vie et ses ouvrages," a series of nine long articles in the *Gazette des beaux-arts* from 1 May 1867 to 1 September 1868; these were published with the same title as a single volume in 1870. The same year saw the publication of Henri Delaborde's important study, *Ingres, sa vie, ses travaux, sa doctrine, d'après les notes manuscrites et les lettres du maître* (Paris: Plon, 1870), reprinted in 1984. All of these were superseded by Henry Lapauze, *Ingres, sa vie et son oeuvre (1780-1867), d'après des documents inédits* (Paris: G. Petit, 1911). Several additional studies were published in the following decades, but few were as interpretive, or as insightful, as Jean Alazard, *Ingres et l'Ingrisme* (Paris: A. Michel, 1950), which not only recounted Ingres' biography but sought to discuss Ingres' art on a broader plane. A modern approach is taken by Robert Rosenblum, *Ingres* (New York: Harry Abrams, 1967), an extremely useful introduction to Ingres' work, with the author's usual perceptiveness of his art discussed broadly in the introductory text, and then in the 48 works selected as representative examples. Also notable is Daniel Ternois, *Ingres* (Paris: F. Nathan, 1980) and the particularly sumptuous edition of Ingres' work presented by Georges Vigne, curator of the Musée Ingres

in Montauban, in *Ingres* (Paris: Citadelles et Mazenod, 1995), which contains 300 illustrations of which two-thirds are in colour. See too Valérie Bajou, *Monsieur Ingres* (Paris: Adam Biro, 1999), which offers more than 200 illustrations and fine details, as well as a stimulating text.

Ingres' correspondence began to be explored by Jules Momméja, "La correspondance d'Ingres," *Réunion des Sociétés des beaux-arts des départements*, 1888, pp. 729–41, but was significantly broadened by L. A. B. Boyer d'Agen, ed., *Ingres d'après une correspondance inédite* (Paris: H. Daragon, 1909; 1926). Ingres' letters and aphorisms on art were collected in Ingres, *Pensées* (Paris: Ed. De la Sirène, 1922); Idem, *Écrits sur l'art: Textes recueillis dans les carnets et dans la correspondance d'Ingres* (Paris: La jeune Parque, 1947); and Pierre Courthion, *Ingres raconté par lui-même et par ses amis: Pensées et écrits du peintre* (Geneva–Vésenaz: P. Carlier, 1947–48, 2 vols.). More substantive are Daniel Ternois, *Lettres d'Ingres à Marcotte d'Argenteuil* (Nogent-le-Roi: Librairie des arts et métiers, 1999–2001, 2 vols.; the first volume contains the actual letters with annotations; the second volume is a very useful dictionary of names, places, etc. noted in the correspondence), and Idem with Marie-Jeanne Ternois, *Lettres d'Ingres à Gilibert* (Paris: H. Champion, 2005).

There are dozens of specialised studies, two of which treat eyewitness accounts of Ingres' working habits and studio by former students: Amaury-Duval, *L'atelier d'Ingres* (Paris: G. Crès, 1878; reprinted 1993 with notes and annotations by Daniel Ternois); and Raymond Balze, *Ingres: son école, son enseignement du dessin, par un de ses élèves* (Paris: De Pillet et Dumoulin, 1880). Ingres' literary sources are enumerated by Norman Schlenoff, *Les sources littéraires de Jean-Auguste-Dominique Ingres* (Paris: Presse universitaire de France, 1956). The best approach through a feminist perspective is Carol Ockman, *Ingres's Erotic Bodies: Retracing the Serpentine Line* (New Haven–London: Yale University

Press, 1995). The importance of fashion in Ingres'
female portraits, an important consideration,
is examined in depth by Aileen Ribeiro, *Ingres
in Fashion: Representations of Dress and
Appearance in Ingres' Images of Women* (New
Haven–London: Yale University Press, 1999).
Important too as a vehicle for Ingres studies are
the many volumes of the *Bulletin du Musée
Ingres*, which since 1956 has published proficient
articles on almost every aspect of Ingres' life and
works. The Musée Ingres has also been home to
a variety of colloquia on several major themes in
his work, including "Ingres et le néo-classicism,"
1975; "Ingres et son influence," 1980; "Ingres et
Rome," 1986; "Ingres et ses élèves," 1999.

[1]
Frédéric Elsig
*Painting in France
in the 15th Century*

[2]
Fabrizio D'Amico
Morandi

[3]
Antonio Pinelli
David

[4]
Vincenzo Farinella
Raphael

[5]
Alessandro Angelini
*Baroque Sculpture
in Rome*

[6]
Aldo Galli
The Pollaiuolo

[7]
Edoardo Villata
Leonardo da Vinci

[8]
Giovanni Lista
Arte Povera

[9]
William Hauptman
Ingres

[9] William Hauptman, a specialist in 19th-century painting, lives in Switzerland where he has mounted several exhibitions devoted to 19th-century art. He is the author of the catalogue raisonné of the works of Charles Gleyre (1806–74), a contemporary of Ingres.